MYSTIC

KENT FULLER, MEREDITH FULLER,
LISA SAUNDERS

Images of Modern America

ARCADIA
PUBLISHING

Copyright © 2016 by Kent Fuller, Meredith Fuller, Lisa Saunders
ISBN 978-1-4671-1669-5

Published by Arcadia Publishing
Charleston, South Carolina

Printed in the United States of America

Library of Congress Control Number: 2015957286

For all general information, please contact Arcadia Publishing:
Telephone 843-853-2070
Fax 843-853-0044
E-mail sales@arcadiapublishing.com
For customer service and orders:
Toll-Free 1-888-313-2665

Visit us on the Internet at www.arcadiapublishing.com

To our favorite little Mystic residents, Quinn and Owen, who
particularly enjoyed our "research" on the beluga whales

—Kent and Meredith

To Jim, my husband, who cheerfully endures dusty
corners and simple dinners so I can write

—Lisa

CONTENTS

ACKNOWLEDGMENTS

This book would not be possible without the Mystic residents who climbed into their hot attics to find images, connected us to people who did the same, and contributed their memories and resources to help with captioning. We would like to specifically thank Dorrie Hanna, collections manager of the Mystic River Historical Society; and Michael Spellmon, adult services librarian of the Groton Public Library; for their assistance.

In addition to those whose images were published, we want to thank the following people and organizations who helped tell the story of Mystic: Robert Bankel, Bill Botchis, Katie Bradford, Al Brown, Carol Buggeln, Amby Burfoot, Colleen Clabby, Kirsten Cohoon, Roderick B. Coleman, Carol Connor, Cathy Cook, Courtyard Gallery, Ruth W. Crocker, Richard Dixon, Chris Duncklee, Craig Floyd, Downtown Mystic Merchants Association, Anne Marie Foster, Michael Friedman, Richard and June Froh, Ted Garringer, Michelle Gemma, John Goodrich, Greater Mystic Chamber of Commerce, Rhona Heyl, Frank Hilbert, Lois Hiller, Jim Holley, Patricia Houser, Virgil Huntley, Maggie Jones, John Kennedy, Carol Kohankie, John Koulbanis, Marion Krepcio, Wil Langdon, John Ligos, Marcus Mason Maronn, Susan Massie, Maurice C. La Grua Center, Cindy Modzelewski, Jeni Moore, Mystic Aquarium, Mystic Museum of Art Archives, Mystic & Noank Library, Mystic River Park Commission, Mystic Rotary Club, Allison Kiley Nasin, Margaret Newton, Evan Nickles, Kathy Norman, Jeffrey P'an, Peter Pappas, Annie Philbrick, Beth Quesnel, Therese Ratliff, Joyce Olson Resnikoff, Jim Roy, Judith A. Salerno, Tom Santos, April Sauchuk, Pat Schaefer, Jean Schweid, Karin Stuart, Richard Sylvestre, Marybeth Teicholz, Bill Thorndike, Trade Winds Gallery, Ellery Twining, Lee Umryz, Tricia Walsh, Louisa Watrous, Candice, Liz, and Robert Webb, Madeline H. Wilson, Jim Woolley, and Tim Yakaitis.

We would also like to thank those mentioned below.

Julia B. Constantine documented a changing Mystic and shared her images for all to see.

Images credited to Joan MacGregor Thorp were taken by her parents, Robert and Florence MacGregor. Florence was a member of the Connecticut Daughters of the American Revolution, Anna Warner Bailey Chapter.

Images credited to Mystic bridge tenders were provided by Roderick B. Coleman and came from an informal collection found in the Mystic River Bascule Bridge control house, presumably taken and saved by bridge tenders throughout the years.

Liz Gurley, senior title manager, and Samantha Langlois, acquisitions editor, at Arcadia Publishing advised and encouraged us in the challenging task of collecting and captioning images from a wide variety of sources.

INTRODUCTION

Straddling both sides of the Mystic River is the quaint maritime community of Mystic, Connecticut—a village where the nautical past and present coexist. Now a tourist destination, Mystic was listed among the top 100 "Best Adventure Towns" in America by *National Geographic*.

First settled by the English in 1654, Mystic was once Native American land. The English settlers referred to the river as Mystick (spelling it various ways), a Mohegan word meaning tidal river. This body of water, so central to life in Mystic, is not actually a river but a six-mile narrow bay driven by tides and winds. After the American Revolution, shipbuilding became the major industry in Mystic, because wood was plentiful, Mystic River's banks slope gently to the water, and the waters are protected from the worst of the Atlantic Ocean storms by Fishers Island. Shipbuilding grew to an all-time high during the Civil War with the construction of 57 steamships.

Evidence of Mystic's seafaring past is seen in the occupations of long-ago residents listed on the plaques affixed to historic homes with cast-iron fences and hitching posts that line the streets. Graveyards also attest to Mystic's relationship with the waters of the world, past and present, as several markers are etched with anchors, ships, and the words "Lost at Sea."

Mystic shipbuilding eventually gave way to the production of wool, velvet, and soap. Those industries gave way to award-winning restaurants, charming shops, and museums. The 1970s saw a big increase in tourism, specifically aided by an interest in the country's bicentennial and Mystic's position off the new highway, Interstate 95, with exits 89 and 90. Mystic is conveniently located between New York and Boston and reachable by train, car, or boat. Mystic Seaport and Mystic Aquarium serve as the main draw, attracting hundreds of thousands to the area annually. With its scenic views of tall ships, islands, and secluded coves, Mystic is a prime setting for weddings and movie productions, such as *Mystic Pizza* in 1987 and *Amistad* in 1997.

The Mystic bridge tenders of the iconic Mystic River Bascule Bridge—also referred to as Mystic Highway Bridge, the drawbridge, or the bridge—are at the pulse of Mystic River news. From the bridge house above, the tenders raise the bascule bridge for historic ships from all over the world. They have raised the bridge for yachts belonging to Steven Spielberg and Clint Eastwood and were personally thanked by former president Jimmy Carter for keeping the bridge down during the tightly timed schedule created by the Secret Service for Carter's motorcade. Carter and former first lady Rosalynn stayed at the Whaler's Inn for the 2004 christening of the Navy submarine USS *Jimmy Carter*.

Although casually referenced as a town, Mystic is not actually recognized as a town. It is a census-designated place, a fire district, and a village with its own zip code that lies within the two townships of Groton, west of the river, and Stonington, east of the river. The town of Groton, known as "the submarine capital of the world," had a population of about 40,000 people in the 2010 census; and the town of Stonington, where early European colonists established a trading house, had a population of about 18,500 residents in the 2010 census. In the same census, Mystic's population is recorded as approximately 4,200 permanent residents.

Two of the largest resort casinos in North America are now only a 20-minute drive from downtown. Mohegan Sun (of the Mohegan Tribe) opened in 1996, and Foxwoods (of the Mashantucket Pequot Tribal Nation) opened in 1992. The evolution of Connecticut's beer and wine scene has brought several wineries and microbreweries to the surrounding area, further creating a draw for visitors.

Mystic's transformation since its 300th anniversary, celebrated in 1954, has been vast. Back then, there were more farms and stone wall–lined country roads. Groceries were delivered to doorsteps. At Everbreeze Farm (now the site of S.B. Butler Elementary School), for example, George Denison raised dairy cattle and delivered milk door-to-door from his pickup truck.

Cottrell Lumber Co., which supplied wood for shipbuilding and dated back to the early 1800s, dominated the heart of downtown where the Mystic River Park is today. Santin Chevrolet on Holmes Street stood where waterfront condos went up in the 1980s. A Mobil gas station operated on West Main Street where Bank Square Books is now. There were fields of scrub brush and wildflowers prior to the development of Mystic Aquarium and Olde Mistick Village, a colonial-style shopping center. With the exception of Mystic Seaport, much of what attracts people to Mystic did not exist half a century ago.

The open space that remains is serving as a catalyst for Mystic's modern community. In 2013, Denison Pequotsepos Nature Center acquired the 34-acre Coogan Farm, which features a community-driven giving garden that strives to feed New London County residents in need and a system of trails allowing one to walk or bike to Mystic Seaport, Mystic Aquarium, Denison Homestead, and the Nature Center. The same Mystic Seaport and Mystic Aquarium that lure tourists also serve the community through various educational programs.

The following eclectic collection of images in this book portrays life in Mystic in the last seven decades. All photographs were taken by people who grew up in, live in, or have ties to Mystic, showing through their eyes Mystic's evolution from a working-class maritime village to one that was recently called a "setting for a Hallmark movie" by Pam Gerstheimer, a tourist from New York. She marveled at the picturesque water views and list of annual traditions, such as the Downtown Mystic Holiday Stroll with carolers in top hats, the Cabin Fever Festival & Charity Chowder Cook-Off at Olde Mistick Village, movies on an outdoor screen at Mystic River Park, Pancakes with Penguins at Mystic Aquarium, and the Antique & Classic Boat Rendezvous at Mystic Seaport.

The faces of Mystic scattered throughout this book bring to life members of the community ranging from a fisherman turned artist to a young schoolgirl turned state senator. They have helped make the village what it is today. Everyone who loaned an image to this book shares one common connection: a love for Mystic.

One

ICONIC MYSTIC

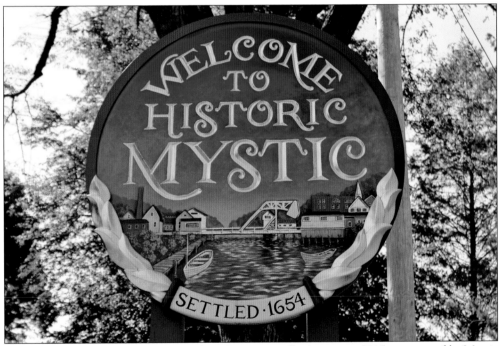

The wooden "Welcome" sign, pictured on Greenmanville Avenue in 2015, was carved by Mystic Seaport ship carvers. Other signs appear on New London Road, Stonington Road, and at the intersection of Noank Road and Water Street. In 1976, the Town of Stonington created the Mystic Bridge Historic District and the Town of Groton created the Mystic River Historic District. Both designations are intended to regulate and preserve the historic appearance of Mystic. (Photograph by Meredith Fuller.)

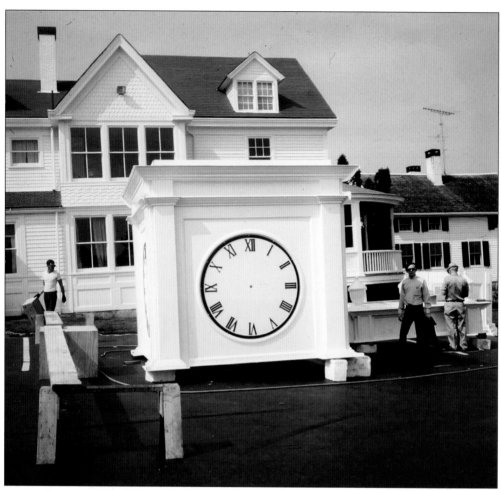

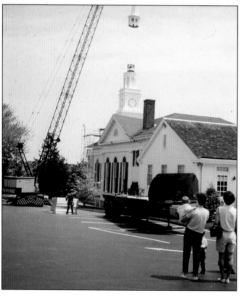

Overlooking the Mystic River Valley is the Union Baptist Church (UBC). When the Great New England Hurricane of 1938 brought its steeple crashing down into its parking lot, there were only funds to fix the gaping hole in the roof, not the steeple. Finally, on May 23, 1969, thanks to a bequest from Walter Beebe, spectators, including students from S.B. Butler Elementary School, watched a giant crane hoist sections of a new 74-foot steeple into place. Taller than the original steeple, it includes an eight-foot-high, 150-pound weather vane—a replica of the one on the Old North Church in Boston—as well as a clock with Westminster chimes that rings hourly and a carillon that plays two concerts daily, at noon and 6:00 p.m. Located on 119 High Street, the church celebrated its 250th anniversary in 2015. (Both photographs by Gene Newton, courtesy of UBC.)

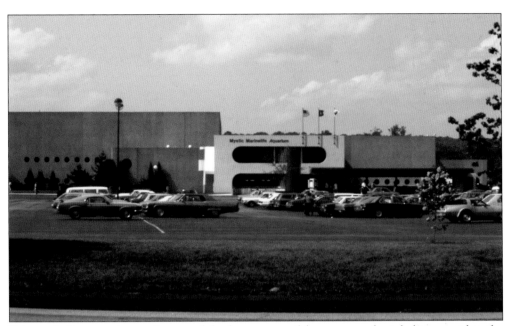

Beluga whales, penguins, sea lions, and sharks are some of the most popular inhabitants within the interactive Mystic Aquarium, but one addition brought to life the former entrance shown above in 1982. The glass crown umbrella-like canopy designed by award-winning architect César Pelli sits atop the entryway to the Mystic Aquarium, as seen below. The abstract atrium, also known as "Ocean Planet Pavilion," was built in 1998 and 1999 during the aquarium's $52 million renovation and expansion. The iconic beluga whale exhibit, with three 20-foot long underwater windows, was also added at that time. (Above, photograph by Julia B. Constantine; below, photograph by Edward L. Fritzen.)

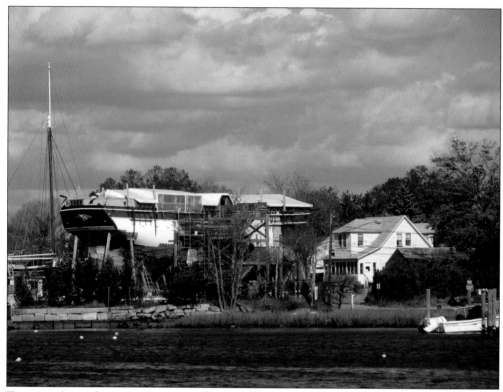

Towering above a home at the corner of Bay and Isham Streets in 2011 is the sole surviving wooden whaleship in the world, the *Charles W. Morgan*, undergoing restoration at Mystic Seaport. The *Morgan* has witnessed floggings, stowaways, drownings, desertions, amputations, and burials at sea. Launched from New Bedford, Massachusetts, during the height of the whaling industry in 1841, the *Morgan* arrived at Mystic Seaport in 1941. (Photograph by Lisa Saunders.)

Kathy Norman sits on the stern of her boat heading north on the Mystic River in 1996, while the *Sabino* heads south. The former powerhouse for the Groton-Stonington Street Railway System (which now houses condominiums) is seen in the background. (Photograph by Allan Ferguson.)

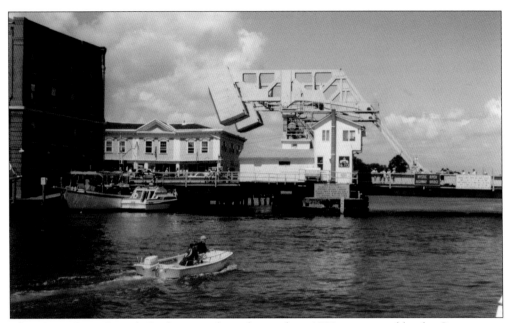

The Mystic River Bascule Bridge, seen from the south in 1998, is operated by the Connecticut Department of Transportation and is the oldest of its kind running in the United States. The bascule bridge is lifted to allow vessels to pass through on an hourly basis in the warmer months and on demand in the winter. The bridge is opened approximately 2,200 times each year. (Photograph by Richard Dixon.)

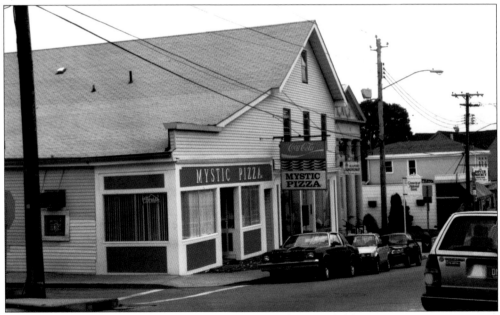

Since the 1988 release of *Mystic Pizza* starring Julia Roberts and debuting Matt Damon, visitors have flocked to the restaurant that inspired it, pictured here in 1989. Originally named Ted's Pizza, it was renamed Mystic Pizza in 1973. When screenwriter Amy Jones vacationed here, Mystic Pizza inspired her to write about three waitresses who serve "a slice of Heaven." The restaurant is located at 56 West Main Street. (Photograph by Marilyn Bebeau.)

Many historic homes in Mystic have signs that provide the date of construction and the name and occupation of the original owner. These were researched in the 1970s under the auspices of the former Mystic Junior Woman's Club. Copies of those research files are available at the Mystic River Historical Society and at the Mystic & Noank Library. (Photograph by Ellery Twining.)

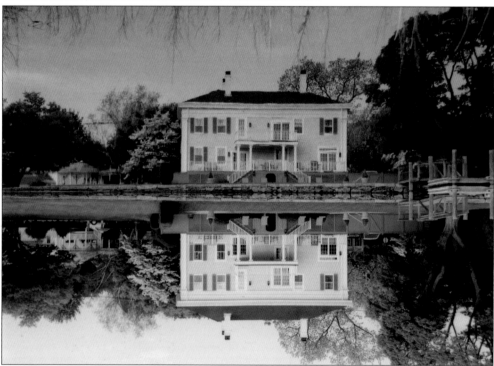

This photograph, taken from Holmes Street in 2008, shows the back of 10 Willow Street. Seen reflected in a cove, the home was built in 1853 for George W. Noyes, a banker who married three times. He outlived his first two wives and had nine children. Family members lived there until 1964. (Photograph by Marion Krepcio.)

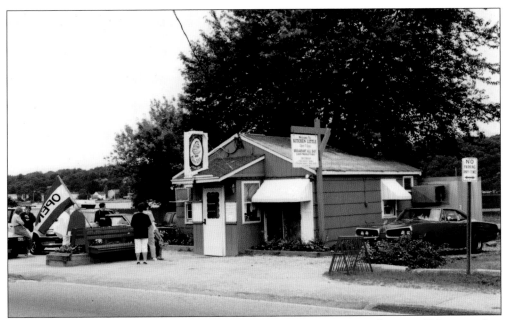

Kitchen Little, currently located at Mystic River Marina, got its start in this cozy 400-square-foot space, shown here in June 2001, on Route 27 just north of Mystic Seaport. Florence "Flo" Klewin (1944–2013) bought the restaurant in 1986 from Susan Davis after five years in business. Flo's son Jim Woolley is the current owner. (Courtesy of Kitchen Little.)

Rachael Ray (right) visited Mystic in August 2004 to shoot an episode of *$40 a Day* for the Food Network. Her breakfast stop was at Kitchen Little, where she had buttermilk pancakes with cinnamon-sugar, butter, maple syrup, and a Diet Coke, and left a 20 percent tip—all totaling $7.35. Rachael is pictured here with Mystic's beloved Flo on the back patio of the original Kitchen Little location, overlooking the Mystic River. (Courtesy of Kitchen Little.)

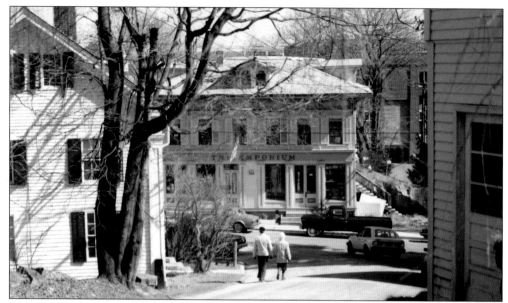

The Emporium, pictured from up the hill on New London Road in 1985, was opened in 1965 and closed in 2013. The location at 15 Water Street will never be the same. Its fun and eclectic gift shop, art gallery, and Halloween costume basement were cherished by locals and tourists alike. (Photograph by Evan Nickles.)

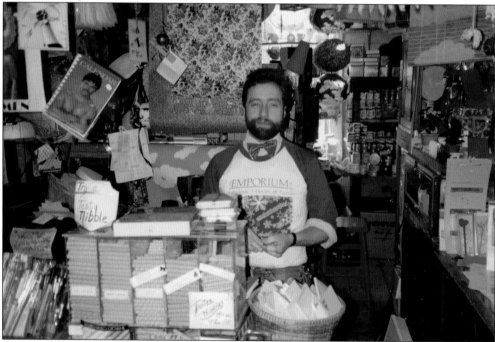

Evan Nickles, photographed by his mother in the early 1980s, and Robert Bankel purchased the Emporium around 1977. As an exterior sign read, the store carried "convenient articles in abundance, tomfooleries, notional whimseys, and oddities." The Emporium will be remembered for its "three floors of fun" and "never know what you'll find" kind of experience. (Photograph by Porta Nickles.)

B.F. Clyde's Cider Mill, family-owned and operated since it opened in 1881, is the only steam-powered cider mill in the United States. Its cider-making demonstrations, apple cider, hard cider, apple wines, and cider donuts attract throngs of visitors between September and December every year. (Courtesy of B.F. Clyde's Cider Mill.)

Jack Bucklyn (left), former owner of Clyde's, is pictured standing in the mill holding a newly constructed rack with his daughter Annette (sitting), Annette's husband Harold, and their young daughter Amy around 1977. At that time, the mill doubled as the store until 1999, when a separate building was constructed for retail. (Courtesy of B.F. Clyde's Cider Mill.)

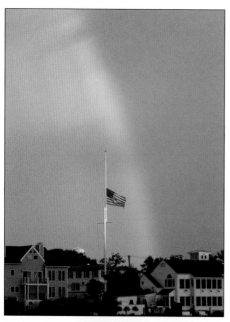

This rainbow over Mystic's Liberty Pole, currently located on the corner of Holmes Street and US Route 1, was photographed on July 24, 2015. The flag is at half-staff for five servicemen killed in a terrorist attack in Tennessee on July 16. Mystic's Liberty Pole was first erected during the Civil War. Since then, it has stood in several Mystic locations and was moved to its present location in 1886. John Kennedy, president of the Mystic Flag Committee, said, "We have been told by reliable sources that Mystic's 113-foot Liberty Pole is the tallest freestanding flagpole in the Northeast." (Photograph by Wil Langdon.)

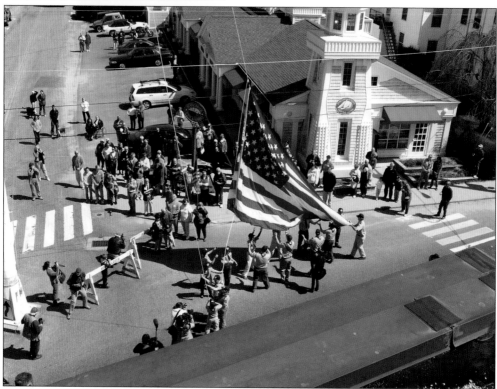

Pictured in April 2005 from the roof of the Whaler's Inn is Boy Scout Troop 76 assisting the Mystic Flag Committee hoisting the 15-foot-by-30-foot flag up the Liberty Pole in celebration of the Doolittle Raiders' 63rd reunion. As part of the ceremony, two B-25 bombers, plus a P-51 fighter escort, flew overhead. Col. Richard Cole (Doolittle's copilot on the Japanese raid) was at the controls of the lead B-25. (Photograph by Wil Langdon.)

Two

IN THE NEWS

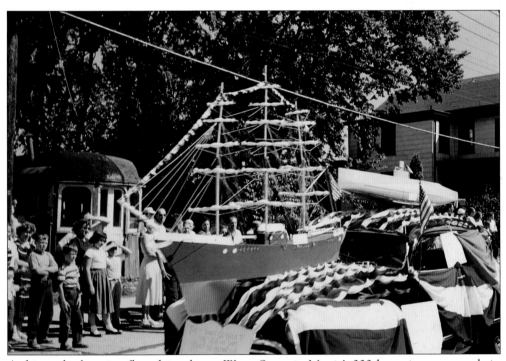

A ship and submarine float drives by on Water Street in Mystic's 300th anniversary parade in 1954. "Bendett's Trolley" (left) belonged to the Groton & Stonington Street Railway until its retirement in 1928. Henry Bendett later used it as his ham radio shack until his death in 1985. The trolley car was removed to the Seashore Trolley Museum in Kennebunkport, Maine, in 1989. (Photograph by Francis Gross, courtesy of Mystic River Historical Society.)

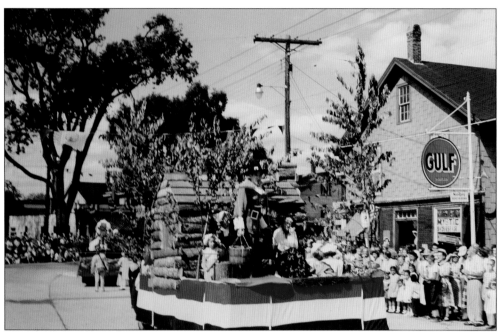

In the mid-1600s, a number of English settlers were granted large parcels of land in the Mystic area, which celebrated its 300th birthday in 1954. From June 29 through September 15, the Mystic Post Office stamped every piece of canceled mail: "Mystic 1654-1954 Celebrating 300 Years of Seafaring History." Children lit 300 candles on a giant cake, and organizations participated in a 30-float parade on Saturday, July 17, 1954. The log cabin float on Water Street (seen above) was sponsored by American Legion Post No. 55. The Gulf station (right) stood where Coldwell Banker Real Estate is today. Below, the women and children dressed in colonial costumes march on Water Street. The house in the background is now Pizzetta restaurant. (Both photographs by Francis Gross, courtesy of Mystic River Historical Society.)

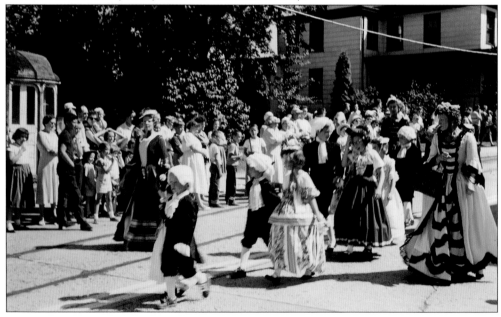

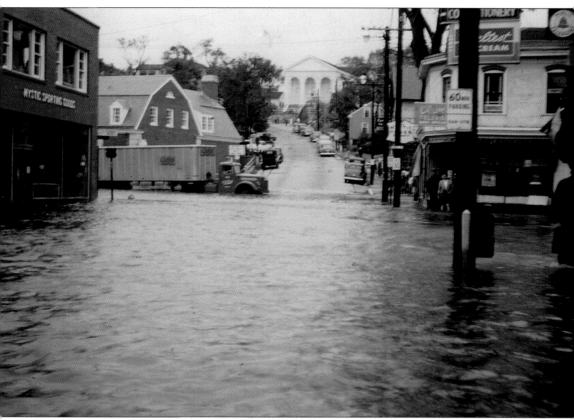

West Main Street facing west is pictured after Hurricane Carol hit on the morning of August 31, 1954. Coming ashore in Old Saybrook, the Category 3 hurricane left 65 people dead and crops severely damaged throughout eastern Connecticut, all of Rhode Island and eastern Massachusetts. Storm surge levels ranged from 10 to 15 feet from the New London area eastward. (Photograph by Virgil Huntley, courtesy of Mystic River Historical Society.)

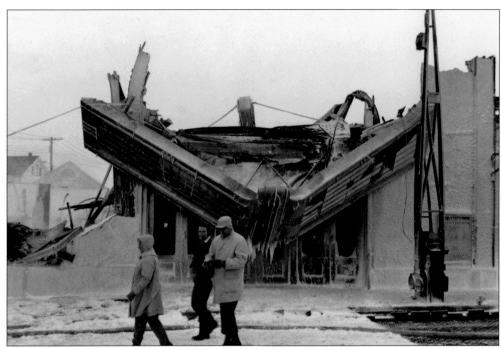

The "Great Mystic Fire" will never be forgotten by those in town on December 12, 1960. Mystic has an extensive history of downtown fires; however, this was tabbed as the worst in the village's history. Two downtown business blocks on either side of East Main Street, adjacent to the drawbridge, were obliterated. Nine stores, six offices, and Mystic's only movie theater were completely destroyed, amounting to more than $1 million in damages. Virgil Huntley, a longtime resident of Mystic, remembers the surreal day: "I awoke to the fire alarm and the sky was pink in the swirling snow. I remember the fire as I tried to walk through the smoke and water from the bridge to the Mystic Post Office where I worked. I could not see my way and got up to my knees in water, so I went home to Pearl Street and drove to the post office by way of Old Mystic." (Both photographs by Robert Jones, courtesy of Maggie Jones.)

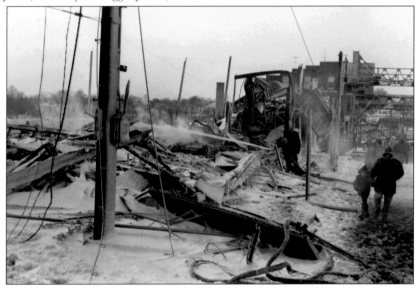

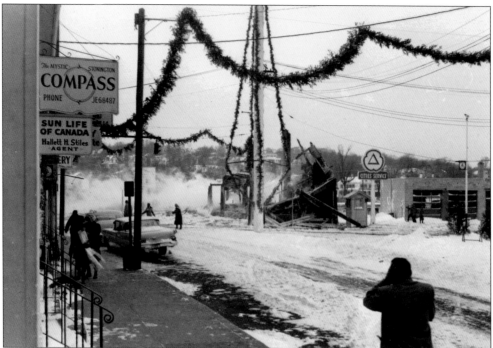

Howling winds as strong as 60 miles an hour fueled the out-of-control fire. Over 200 volunteer firefighters from the extended area came to assist. Mystic Fire Department chief Frank Hilbert, then just five years old, remembers his mother walking him down to see the destruction the morning after. He recalls it being so cold that the hoses froze. He witnessed firemen dragging the frozen solid hoses up the street with a backhoe to be thawed. The Strand Theatre, built in the early 1920s, was completely leveled in the 1960 fire and was never reconstructed. The only business rebuilt on the original site was Noyes Dry Goods, owned by Daniel B. Fuller. (Both photographs by Robert Jones, courtesy of Maggie Jones.)

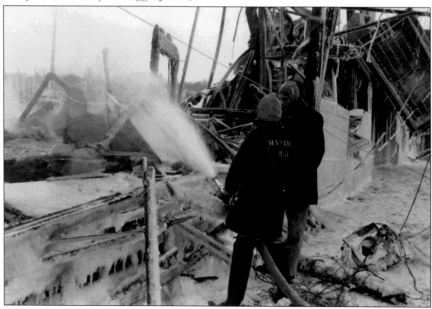

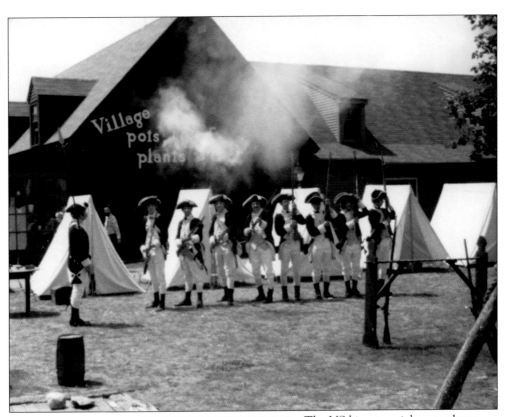

The US bicentennial, a year-long national celebration, included commemorations of the actions leading up to the American Revolution. It culminated on July 4, 1976, with the 200th anniversary of the adoption of the Declaration of Independence. Interstate 95 made Mystic a convenient destination for bicentennial tourism. Revolutionary War reenactors are pictured above in front of Village Pots and Plants at Olde Mistick Village during the Fourth of July weekend. The Mystic Garden Club float, pictured at left with the theme "You've Come a Long Way, Baby," rolls along West Main Street near the corner of Gravel Street during the parade on Sunday, July 4, 1976. Adelaide Hirsche is in the gazebo, and Marcie Brensliver is on the chaise lounge. (Above, photograph by Julia B. Constantine; left, photograph by Judy Hicks.)

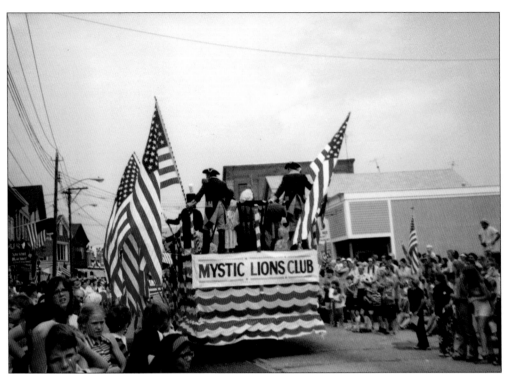

The bicentennial celebrations in Mystic culminated on Sunday, July 4, 1976, with a parade celebrating the birth of the United States of America. The floats of the Mystic Lions Club (above), a community service organization, and of the Noank Historical Society with Mark Turner, a Mystic banker, as a lobsterman (below), are pictured on West Main Street in views facing east between Pearl and Gravel Streets. Bee Bee Dairy in the grey structure (below right) was a popular local dining spot formerly on the site of the Maxwelton Building, erected in 2004. (Both photographs by Julia B. Constantine.)

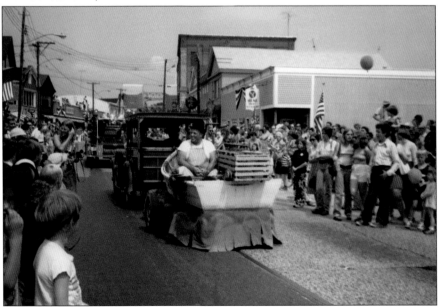

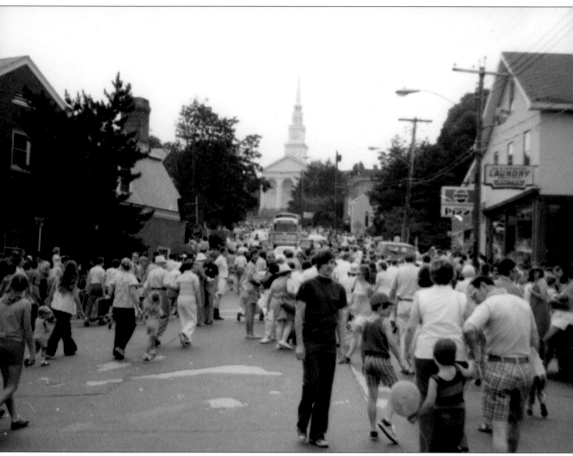

This view of West Main Street looking toward Baptist Hill was taken during the Fourth of July Bicentennial Parade in 1976. Mystic Pizza (right) was originally Ted's Pizza before Stefanos Zelepos bought the business in 1973 and changed its name, which inspired the 1987 movie *Mystic Pizza*. (Photograph by Julia B. Constantine.)

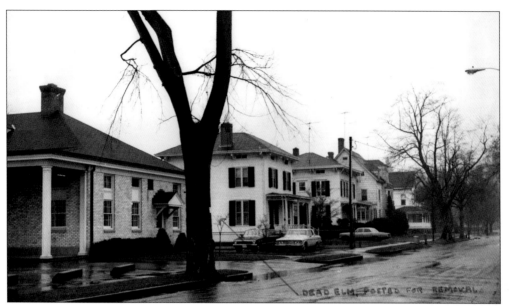

Dutch elm disease destroyed the American elm trees that once lined the shady streets of Mystic. It was caused by a fungus spread by the elm bark beetle, and killed elm trees by the hundreds of thousands across the country. Seen here in the foreground on East Main Street, near the corner of Broadway Avenue, is a dead elm tree in 1967, slated for removal. (Courtesy of the Mystic Garden Club.)

This photograph of the former Old Mystic Baptist Church in Old Mystic on Route 27 was taken after the northeastern US blizzard of 1978, a nor'easter that dumped nearly two feet of snow on the region on February 6 and 7. Gov. Ella T. Grasso shut Connecticut down for three days, and President Carter declared the state, along with Rhode Island and Massachusetts, a federal disaster area. (Photograph by Richard Dixon.)

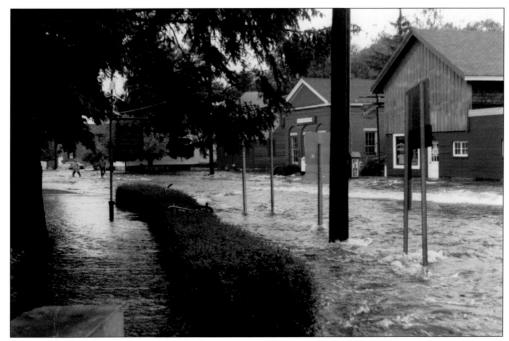

Whitford Brook exceeded its banks during a three-day rainstorm in June 1982, causing major flooding to Route 27 in Old Mystic. The region saw up to 10 inches of rain in the weekend deluge. (Courtesy of Indian and Colonial Research Center.)

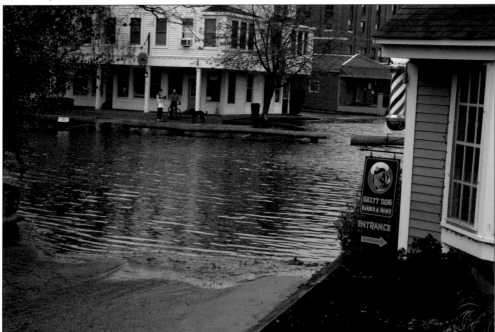

Mystic was hit by Superstorm Sandy on Monday, October 29, 2012. The Mystic River overflowed its banks, as seen here at 9:39 a.m. in front of the shop A Taste of New England, located at 12 Steamboat Wharf. Sandy was the deadliest hurricane of the 2012 Atlantic hurricane season and the second-costliest hurricane in US history, after Katrina in 2005. (Photograph by Richard Newton.)

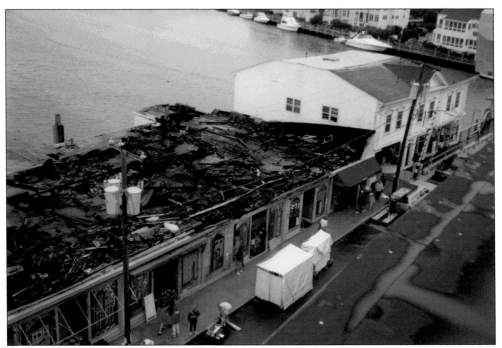

On March 6, 2000, a fire caused significant damage to the Central Hall Block Building on West Main Street. This was the fourth time since 1863 that this same location, which sits on pylons above the Mystic River, succumbed to fire. Plans to redevelop have been submitted and approved by the Town of Groton. Condominiums and shops are intended for the empty space. (Courtesy of Greater Mystic Chamber of Commerce.)

The John Mason Monument, dedicated in 1889 and pictured here at the intersection of Pequot Avenue and Clift Street in fall 1993, commemorates Capt. John Mason's victory over the Pequot Indians in 1637. The English, under Mason's command, attacked the Pequots near this site. As a result of controversy in the 1990s about this incident, sometimes referred to as the "Mystic Massacre," the statue was relocated to Windsor, Connecticut, in 1995. (Photograph by Judy Hicks.)

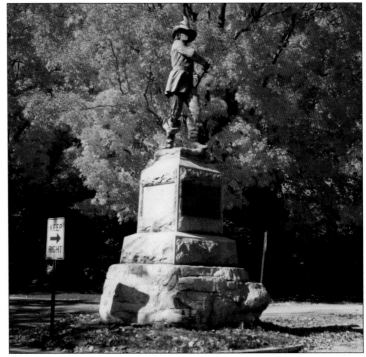

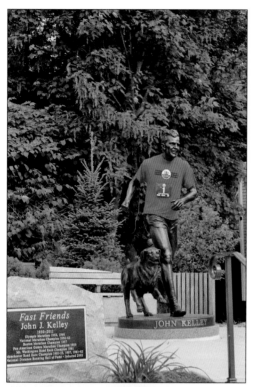

The larger-than-life statue of Mystic's beloved, inspirational running hall-of-famer, John J. Kelley, stands tall above the hustle and bustle of Main Street's downtown shops and restaurants. It was unveiled in 2014 in front of a crowd of John's loved ones. "Kell," as his friends called him, is wearing an inaugural Mystic Half Marathon & 10K Race T-shirt on race day in 2015. (Photograph by Meredith Fuller.)

Local running legend, family man, coach, teacher, mentor, and Mystic business owner John J. Kelley (1930–2011) is shown here sitting at his kitchen table (on Pequot Avenue) writing one of his weekly articles. Some of Kelley's running achievements included winning the 1957 Boston Marathon and eight consecutive National Marathon Championships. He also participated in two Olympic marathons. (Photograph by W.R. Hurshman.)

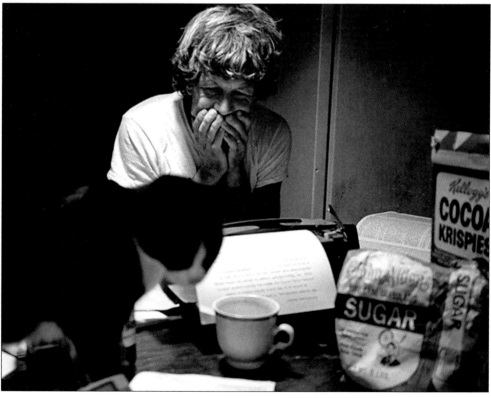

The *Mayflower II* is towed up Mystic River to Mystic Seaport on December 5, 2015, from Plymouth, Massachusetts, to undergo its second phase of restoration. It is scheduled to be completed by the 400th anniversary of the Pilgrims' arrival at Plymouth in 1620. Owned by Plimoth Plantation, the *Mayflower II* was built in England and sailed to the United States in 1957. (Photograph by Kent Fuller.)

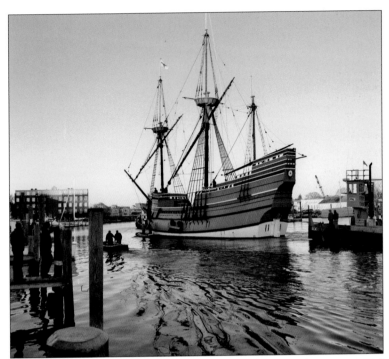

The Freedom Schooner *Amistad*, pictured heading south to the Mystic River Bascule Bridge, was launched from Mystic Seaport on March 25, 2000. The *Amistad*, a replica of *La Amistad*, was built by shipyard staff and students from Connecticut vocational schools for Amistad America, Inc., to educate the public about the 1839 slave revolt on *La Amistad*. The *Amistad* is now owned by Discovering Amistad, Inc. (Photograph by April Sauchuk.)

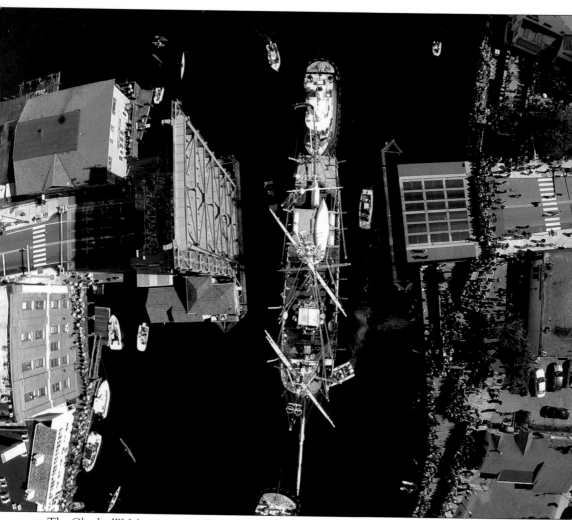

The *Charles W. Morgan* passes through the lifted Mystic River Bascule Bridge on her 38th voyage to historic parts of New England on May 17, 2014. Thousands of people gathered on both sides of the river to witness the *Morgan* venture through the bridge for the first time since 1941, while local drone photographer Tim Yakaitis took a different perspective from approximately 150 feet above. (Courtesy of DroneOn.com.)

Three

COMMUNITY

Mystic River Park sits between the Mystic River and Cottrell Street. The park has become a gathering center for the community. It is a place to watch the action near the drawbridge and is the locale of many special events, like evening concerts in the park during the summer months. (Courtesy of Mystic bridge tenders.)

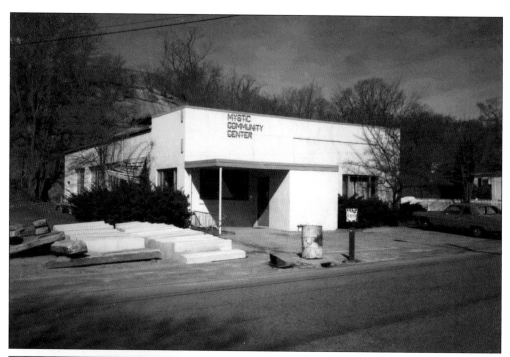

At one point, the Mystic Community Center, which was organized in 1945, offered over 400 activities, from basketball to ski trips. Teen dances were held there, and it served as common ground for the kids from opposite sides of the river. Pictured at left, Roger Quesnel (1933–2013) was the executive director for 29 years, from 1960 to 1989, and is remembered as the spirit of the center. The Pearl Street location was a modest-sized former automobile garage, but it was packed full of programs and a commitment to the people of Mystic and surrounding areas. (Above, courtesy of Joan MacGregor Thorp; left, courtesy of Beth and Jeff Quesnel.)

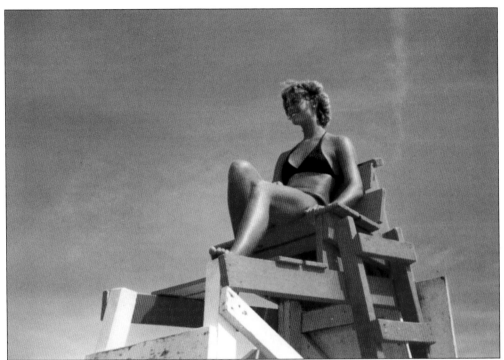

In this c. 1972 image, a Mystic Community Center (MCC) lifeguard sits on duty at Williams Beach off Mason's Island Road. The center, formerly on Pearl Street, relocated to its larger 22,000-square-foot facility in 1983. In the summer of 2003, the MCC became the Mystic branch of the Ocean Community YMCA. (Courtesy of Charter Oak Scanning.)

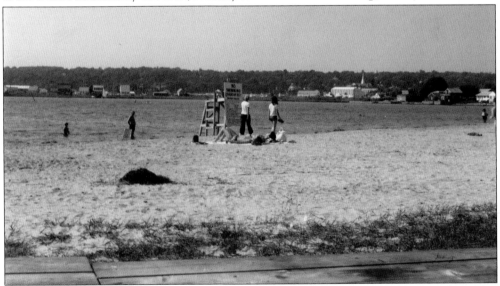

The 120-foot beachfront along the Mystic River, seen here in 1986, is free and open to the public. Dedicated in 1954, Williams Beach Park is located at 1 Harry Austin Drive and used by the Mystic branch of the Ocean Community YMCA for its day camp. A sign warns of a sharp drop-off in the water and that there is "No Lifeguard on Duty; Swim at your own Risk." (Courtesy of Acme Wire Products Co., Inc.)

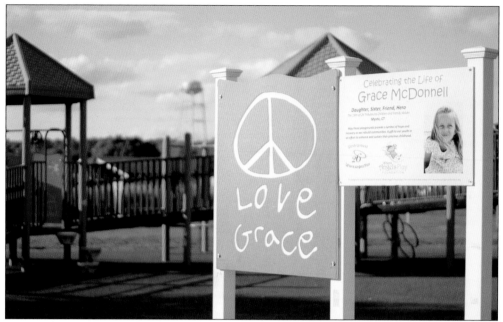

A playground addition to the Mystic YMCA in 2014 celebrates the life of Grace McDonnell, who was lost in the tragedy at Sandy Hook Elementary School in Newtown, Connecticut. The play structure has enlarged replicas of the seven-year-old's artwork embedded into its walls, a touching tribute to sweet Grace, who loved to paint and wanted to be an artist someday. (Photograph by Meredith Fuller.)

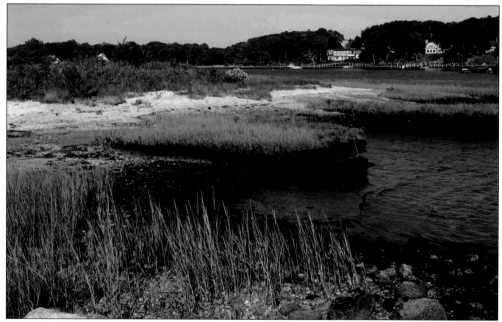

Ram Point is located at the southwesterly peninsular tip of Mason's Island along the Mystic River. It was acquired by Avalonia Land Conservancy in 1969, the very first land acquisition by this nonprofit organization dedicated to preserving land in southeastern Connecticut. Ram Point is open to the public but accessible by water only. (Photograph by Beth Sullivan.)

Buoy 20 (pictured here in the 1970s during the winter lobster season) marks Ram Island Reef. Mystic's Ram Island, a private island of less than 20 acres south of Mason's Island, was once the site of a Victorian-era hotel that was frequented twice a day by steamships from New York City and Boston. Fires claimed a barn and then a home on the island in 2013 and 2014 respectively. (Photograph by Paul Watts.)

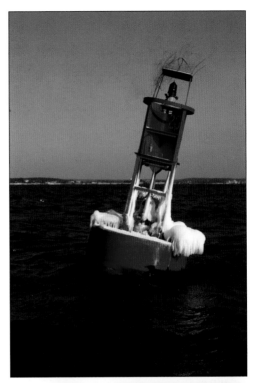

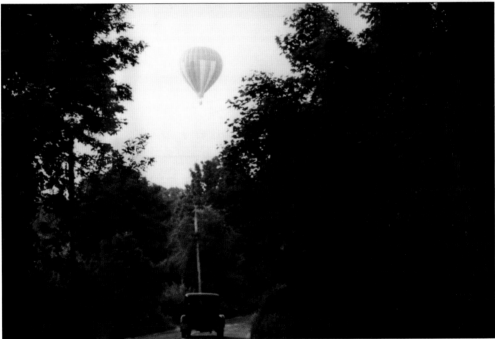

When hot-air balloonist Gil Foster found himself a little lost in the fog in 1983, he lowered himself to ask Herbie Maxson, who was driving along Pequotsepos Road in his antique Ford Model A, where he was. This photograph was snapped by Glenn Dean from his motorcycle once he got over the shock of a balloon appearing out of the mist. (Photograph by Glenn Dean.)

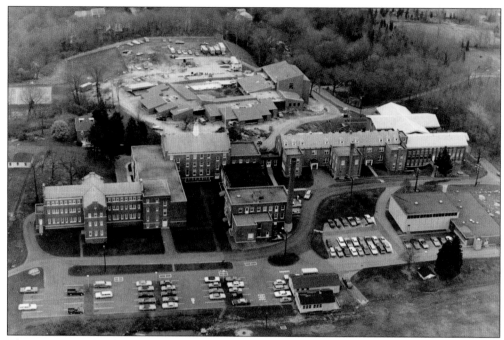

The Mystic Oral School for the Deaf, reorganized as such in 1895, taught children to speak until 1980 when it closed. The state assumed ownership as the Mystic Education Center, and the sprawling 100-plus-acre grounds became home to athletic teams, a public swimming/therapy pool, a day care center, fire department training grounds, and more. The property is now vacant. (Photograph by Military Department, State of Connecticut, courtesy of Indian and Colonial Research Center.)

Eighth-grade teacher George McKenna (left) and seventh-grade teacher Julia McKenzie are pictured in front of Broadway School at the June 1955 graduation. The Broadway School, located on the corner of Greenmanville and School Street, was built in 1909. It was later converted into apartments and then, more recently, 21 condominium units. (Courtesy of Janet Purinton.)

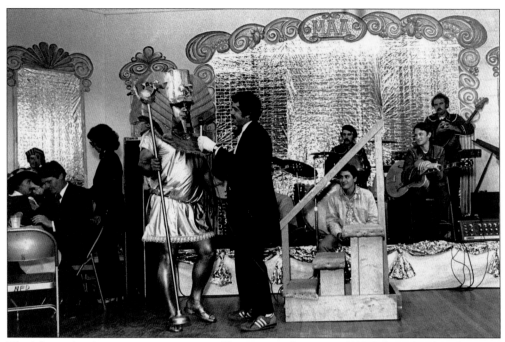

The Mystic Art Association was organized by a group of artists in 1913. It later developed into an educational, nonprofit corporation. It was a place of free expression, illustrated by this photograph from a costume ball in 1978. Today, as the Mystic Museum of Art (MMoA), it is an arts and culture center maintaining a permanent collection and operating to the standards of the museum industry. (Courtesy of MMoA Archives.)

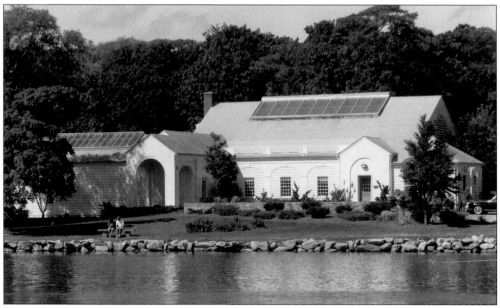

Pictured is the back of the Mystic Art Association in 1990. The board of trustees and members voted in 2004 to change the name to Mystic Arts Center to better reflect their vision for a community-driven organization. In 2016, the Mystic Arts Center was rebranded as Mystic Museum of Art. (Courtesy of MMoA Archives.)

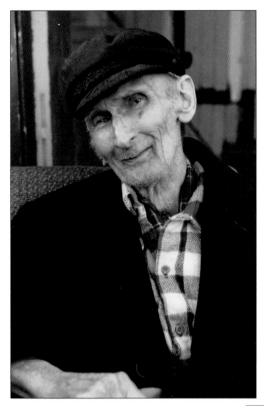

Born in Mystic, Capt. Ellery F. Thompson (1899–1986) was a fisherman off the waters of southern New England. An author and artist, Thompson claims to have been one of the first rumrunners in the 1920s. Thompson, along with his dragger, the *Eleanor*, are acknowledged in scholarly publications on marine life for their assistance collecting samples in the Long Island Sound. Thompson is seen here around 1983 on the porch of his apartment at Fort Rachel Marina. He is buried at Elm Grove Cemetery with a headstone showing a dragger and the words: "Imagine the excitement on the other shore." In addition to writing books and fishing, Captain Thompson painted images of draggers and clipper ships at sea. In 1962, he painted this two-by-three-foot canvas of a woman with fishing vessels and Castle Hill Lighthouse of Newport, Rhode Island, in the background. (Left, photograph by Marion Krepcio; below, courtesy of Marion Krepcio.)

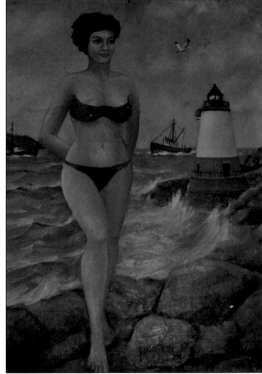

Local resident and artist Jeffrey P'an grew up in the Windy Hill area of Mystic and has been creating vibrant pieces of sculptural blown glass since 1994 upon his return from studying abroad in Murano, Italy. *Egg, Rectangle Cut* (pictured) was made in 2012. P'an also creates one-of-a-kind jewelry and sculptural pieces of all sizes. Locally, P'an's work is showcased at the Mystic Aquarium. (Courtesy of Jeffrey P'an.)

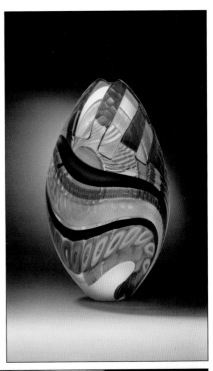

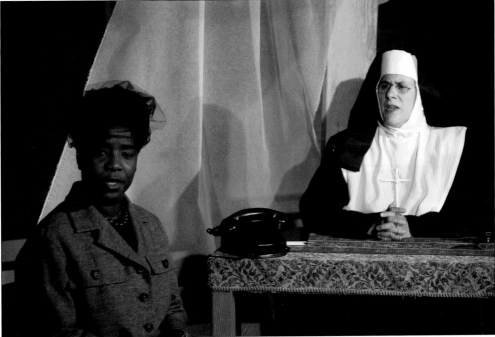

The Emerson Theater Collaborative was formed in 2008 to produce live theater with an emphasis on diversity. Based out of Mystic, the group explores timely issues through original works and modern theatrical classics. In August 2008, it performed its inaugural show, *Doubt: A Parable* by playwright John Patrick Shanley, at the Union Baptist Church. These actors are Camilla Ross (left) and Emma Palzere-Rae. (Photograph by Jack Ross.)

The green arrows on this 1967 photograph of children playing along Willow Street across from the Mystic Post Office show trees planted by the Mystic Garden Club (MGC) as part of its Civic Beautification Project. The MGC was organized in 1924 to encourage the love of gardening and promote civic beautification. (Courtesy of MGC.)

The Mystic Garden Club (MGC) planted a tree and installed a plaque on October 1, 2001, at the Mystic Post Office at 23 East Main Street in memory of the terrorist attack victims of September 11, 2001. The MGC members seen here are, from left to right, Karin Stuart, Sandy Halsey, and Cynthia Benfield. (Courtesy of MGC.)

Mystic local Catherine Welles (Cook) is seen here riding on her turquoise Schwinn bicycle in 1959. She later became a Connecticut state senator and played an instrumental role in securing the state funds for the development of Mystic River Park, which changed the face of downtown. She is a longtime Mystic Lions Club member devoted to her family and public service. (Courtesy of Cathy Cook.)

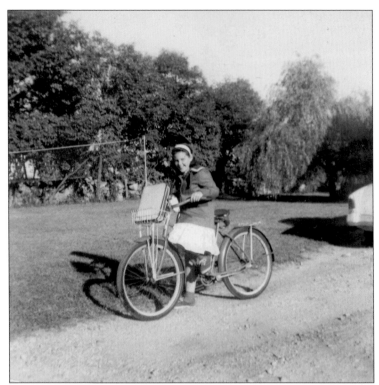

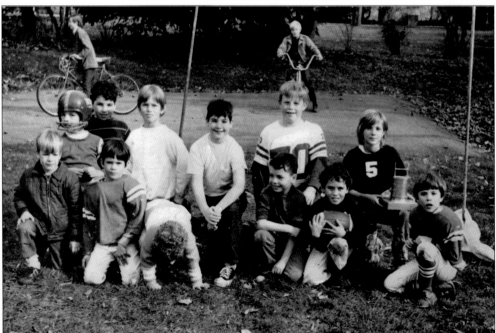

This group of eight-to-nine-year-old West Mystic neighborhood boys, seen here in about 1968 or 1969, played sandlot football on the grounds of S.B. Butler Elementary School. The winning team was awarded the (handmade) trophy, shown on the knee of the youngster wearing the No. 5 jersey. (Courtesy of Cathy Cook.)

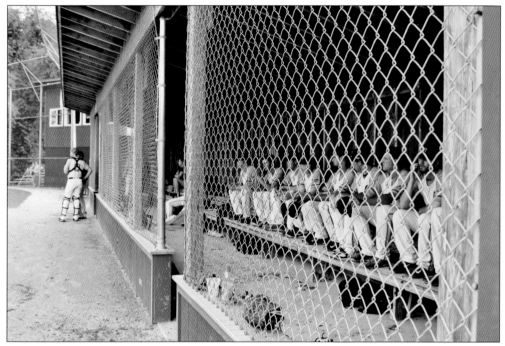

The Mystic Schooners is an elite-level amateur baseball team and member of the New England Collegiate Baseball League. During the summer season, players reside with host families in the area. Their home games are played at Robert E. Fitch High School, on the same field where New York Mets star Matt Harvey once pitched for the Fitch Falcons. (Photograph by Meredith Fuller.)

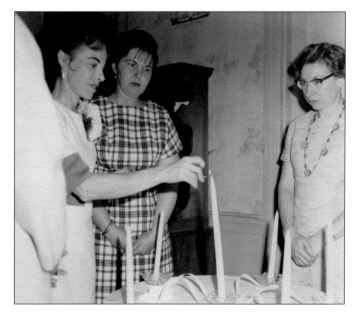

Members of the Mystic Women's Club (MWC) joined the Greater Federation of Women's Clubs in February 1969 to dedicate themselves to community improvement through volunteer service. On May 2, 1969, Jean Stevens (center) and Rena Piechert (right) were installed as the first president and first vice president respectively at the Flood Tide Restaurant (now Harbour House). On the left is Geraldine Johnson, vice president of the New London Women's Club. (Courtesy of MWC.)

David Ferguson (left) chats with his brother Charles Ferguson on the stern of the *Lady*, a 1930s motor yacht. They joined other family members in 1998 on a privately chartered tour of Fishers Island Sound to celebrate the 80th birthday of their mother, Mina Ferguson. The Mystic River Bascule Bridge is in the background. (Photograph by Janet Purinton.)

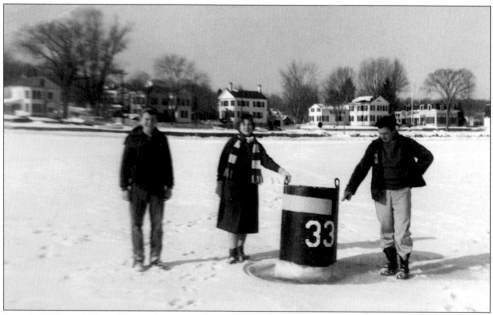

Locals Wil and Carol Langdon and their father, Wilbur "Bill" Langdon, who was the self-appointed "Mayor of Gravel Street," stand on the frozen Mystic River alongside buoy 33 in January 1961. Behind them, their longtime home at 27 Gravel Street, which was built in 1834, can be seen at center. The home was later featured in *This Old House* magazine. (Courtesy of Carol Langdon Kohankie.)

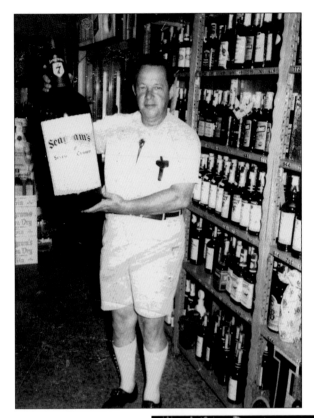

Russell "Russ" Welles is pictured in his package store in 1968. Russ previously owned the Mayflower Restaurant and, in later years, the Plaid Cab Company. He was known for his clam chowder recipe and filling the bellies of firemen and highway crews during blizzards and natural disasters. He was a life member of the Mystic Lions Club. After his retirement, Russ volunteered with special-needs children. (Courtesy of Cathy Cook.)

The Mayflower Restaurant opened in 1948 on West Main Street and moved to a location on Route 27, one mile north of Mystic Seaport, in 1954, after Hurricane Carol flooded the business. The menu included a hamburger served with potato chips and salad for a whopping 69¢, and a root beer was only 10¢. A slice of pie went for a quarter. (Courtesy of Cathy Cook.)

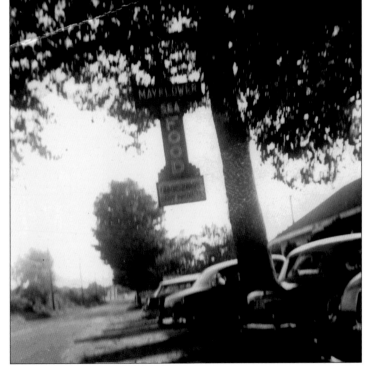

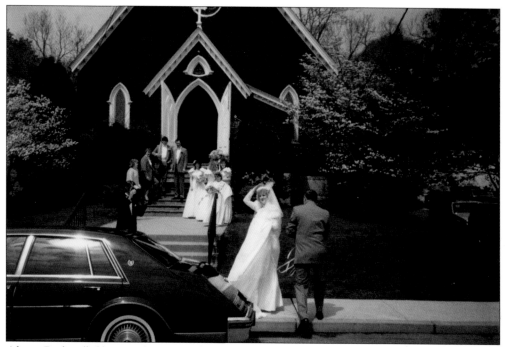

Alison Barber (left) arrived at St. Mark's Episcopal Church with her father, Fred Barber, to marry James Wydler on May 14, 1988. Wydler was a fifth-generation member of the church. The couple began dating after graduating Robert E. Fitch High School. Located on 15 Pearl Street, St. Mark's was organized in 1865 and held its first service in this building on Christmas morning in 1867. (Photograph by Marianne Wydler.)

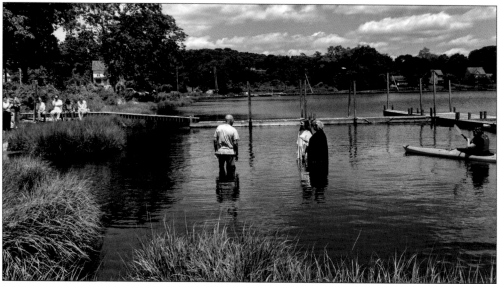

Baptisms in the Mystic River have been taking place since as early as 1842, as documented in an engraving by John W. Barber. Union Baptist Church still holds baptisms in the river, pictured here off River Road on June 9, 2013. Jane Coates is being baptized by Rev. Stacy Emerson with the assistance of church trustee Bill Adams. Observing from her kayak is Megan Barker Strand. (Photograph by Peg Quick.)

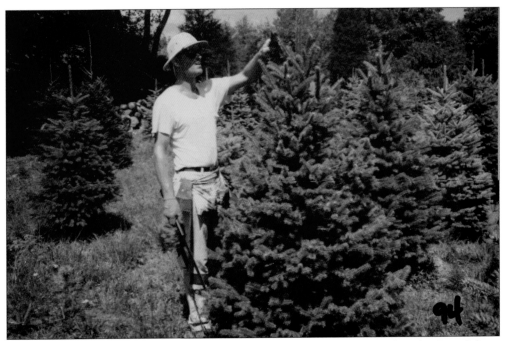

The first trees were planted on Yetter Road Christmas Tree Farm in 1964, but the farm did not open to the public until 1974. The 16-acre farm is managed by Leon "Lee" Umrysz (pictured), who grew up on the property. There are many family members who help run the business, including the shop manager, Michelle Umrysz. Lee's mother, Irene (Whittle) Umrysz grew up just down the road on the Whittle's Willow Spring Farm property. (Courtesy of the Umrysz family.)

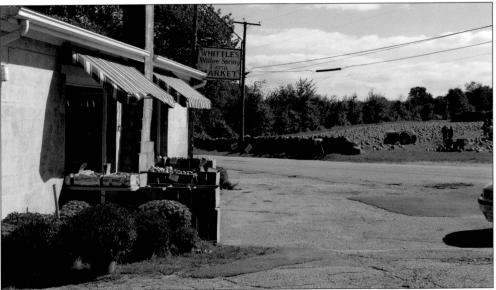

Whittle's Willow Spring Farm, located on Noank Ledyard Road, has been in business for more than 100 years and is a busy summer farm stand in Mystic. Locals flock to Whittle's for fresh local produce, especially corn and apples. Whittle's has an annual pumpkin patch and a colorful selection of potted mums in the fall, just before the doors are shut for the season. (Photograph by Meredith Fuller.)

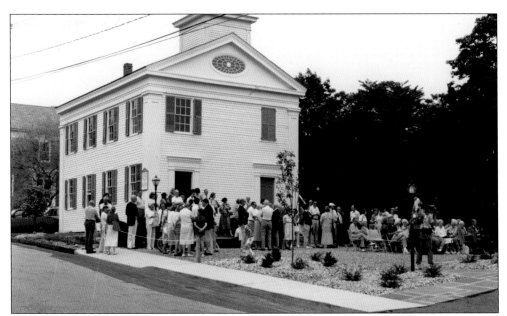

Portersville Academy, built in 1839, has two front doors so boys and girls could enter the school separately. In 1887, the Town of Groton moved the building down High Street to its present site. The Mystic River Historical Society (MRHS) acquired it in 1973 and restored it. Here, MRHS members celebrate the June 21, 1987, opening of the William A. Downes Archives Building, which houses the society's collections next door. (Courtesy of MRHS.)

The Indian and Colonial Research Center (ICRC) was founded in 1965 to house the collection of Eva Lutz Butler's early Americana; acquire and preserve collections of local historic, genealogical, Native American, early colonial, and educational materials; and make these collections publicly accessible. ICRC, pictured here in 1990, is located in the 1856 Mystic Bank building and is in the National and State Registers of Historic Places. (Courtesy of ICRC.)

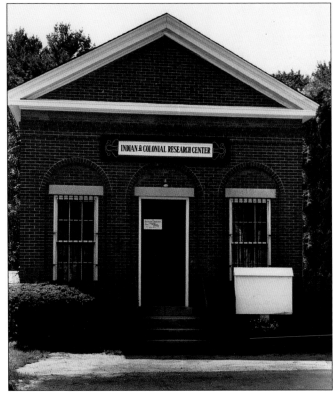

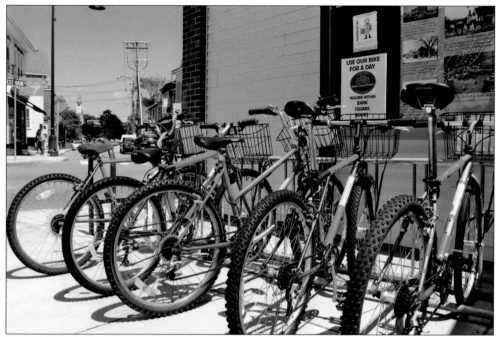

The Mystic Community Bikes program, founded in 2008, began its mission to promote eco-friendly touring of Mystic by bicycle rather than on foot (too slow) or by car (too fast). The collection of lime-green bikes, with helmets and locks, are rented with a refundable $10 deposit from various locations throughout Mystic, including Bank Square Books (pictured), Seaport Marine, and the Howard Johnson Inn. (Photograph by Kent Fuller.)

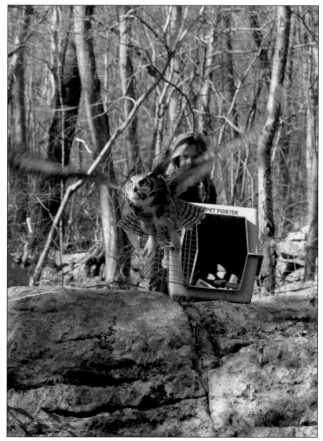

Maggie Jones, executive director of Denison Pequotsepos Nature Center (DPNC), releases a great horned owl a couple days after it was found caught in a trap by its talons in April 2006. In any given year, the nature center takes in approximately 125 birds and mammals in need of care as part of its animal care and rehabilitation program. (Courtesy of DPNC.)

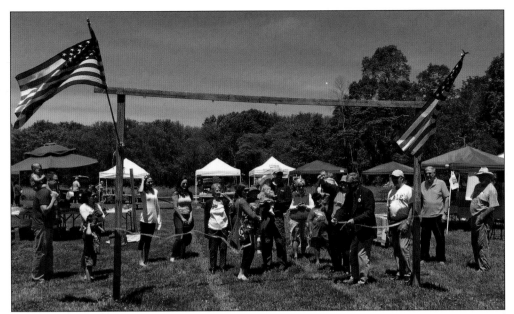

The Denison Farm Market was started by a group of farmers with a passion for growing and nourishing the community. The market is open Sundays, June through October, and is located in a meadow below the Denison Homestead Museum, across the street from Denison Pequotsepos Nature Center. It provides the area with direct access to a bounty of fresh, locally grown fruits, vegetables, and more. (Courtesy of Denison Farm Market.)

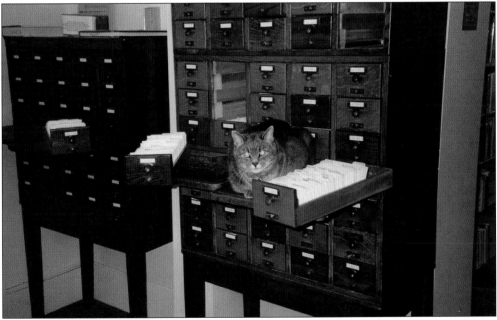

Emily, a stray silver tabby kitten, moved into the Mystic & Noank Library (MNL) in 1989. Fond of riding the elevator, she waited by the door until patrons pushed the button. A guardian of the night, Emily kept the bat and cricket populations at bay. She now lies buried on the library's property under a headstone etched with four paw prints and "Emily, 1989–2006." (Photograph by Joanna Case, courtesy of MNL.)

51

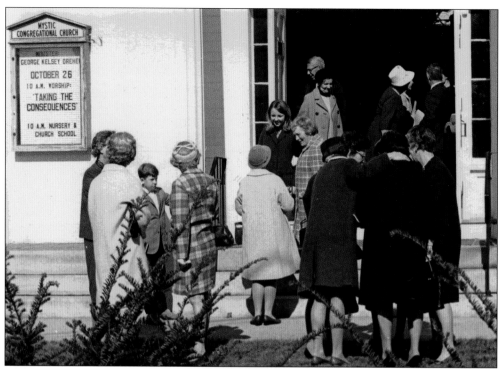

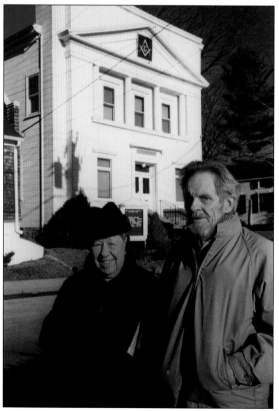

The Mystic Congregational Church, located just blocks from the Mystic River Bascule Bridge on the corner of East Main Street and Broadway Avenue, is more than 150 years old. This image shows a group of churchgoers congregating in the front entrance area in 1968. The minister at the time was George Kelsey Dreher. (Courtesy of Mystic Congregational Church.)

Virgil Huntley (left), a World War II veteran, is pictured in 1997 with Arthur Payne, creator of the Mystic River Scale Model at Mystic Seaport. Huntley is the "memory of Mystic," according to Louisa Watrous of the Mystic River Historical Society. Behind them is the former Masonic Hall at 7 Gravel Street. The 1912 building was sold in 2008 to consolidate Pawcatuck No. 90, Charity & Relief No. 72, and Asylum No. 57 lodges and was converted to condominiums. (Courtesy of Mystic River Historical Society.)

Four

TOURISM

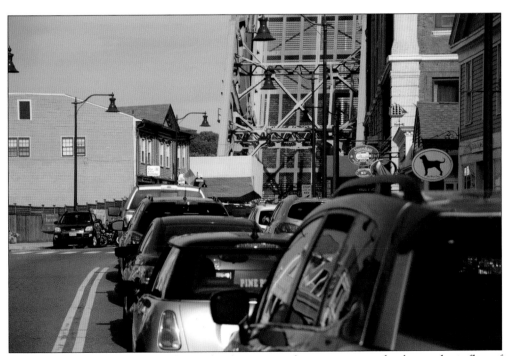

Things get a bit congested on the roads of Mystic in the summer months due to the influx of people and heavy boat traffic. The Mystic River Bascule Bridge is opened hourly at 40 minutes past the hour between 7:40 a.m. and 6:40 p.m. from May 1 to October 31. Locals time their outings accordingly. (Photograph by Edward L. Fritzen.)

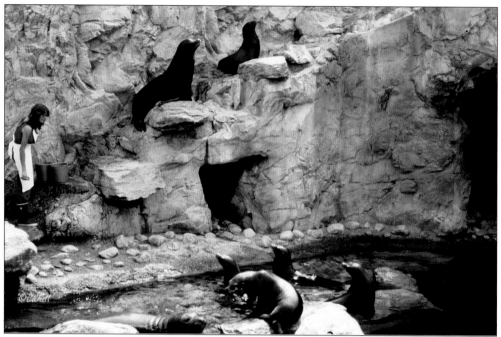

The California sea lions pictured in 1979 were a part of the popular outdoor Seal Island exhibit at the Mystic Aquarium. The 2.5-acre habitat featured five species of seals and sea lions in individual pools. The lions of the sea have been showing off their skills, agility, and lovable personalities during daily shows within the Marine Theater since the early days of the aquarium. (Photograph by William B. Cahill, Trecrowns.)

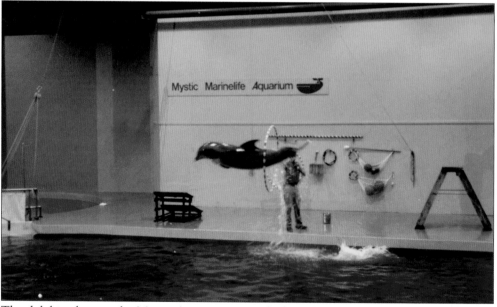

The dolphin show at the Mystic Aquarium started when the aquarium opened in 1973. The Atlantic bottlenose dolphins performed demonstrations in the Marine Theater, as seen in this image from the summer of 1985. In 2001, the aquarium discontinued the dolphin show and a California sea lion show took center stage. (Photograph by Cheryl Kraynak.)

54

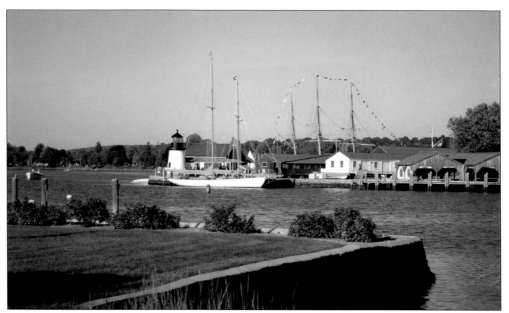

This view of Mystic Seaport, a 19-acre, 19th-century American maritime village museum, was captured in 2015 from across the Mystic River. Mystic Seaport began on December 29, 1929, as the Marine Historical Association, founded by residents Edward E. Bradley, Carl C. Cutler, and Dr. Charles K. Stillman. Its collection includes buildings, sailing vessels, logbooks, photography, model ships, and other maritime artifacts. By the 1990s, Mystic Seaport was widely recognized as the nation's leading maritime museum. (Photograph by Meredith Fuller.)

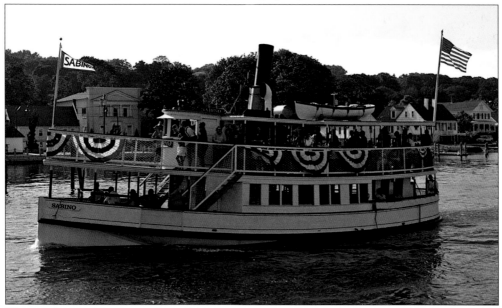

The wooden coal-fired steamboat *Sabino* is pictured in the Mystic River in 2010. Built in 1908 in Maine, she spent most of her career there bringing passengers and cargo between towns and islands. In 1918, she sank in an accident on the Damariscotta River, then operated on the Kennebec River. She came to Mystic Seaport in 1973 and became a National Historic Landmark in 1992. (Photograph by Marcus Mason Maronn.)

This photograph, taken in 1976 near the Exit 90 off-ramp of Interstate 95, shows the highway sign that was added to aid visitors in front of the old outdoor Sunday flea market near the Farm Maid on Route 27. Cash True Value Home Center, which still occupies the building to the left, can also be spotted. (Photograph by Julia B. Constantine.)

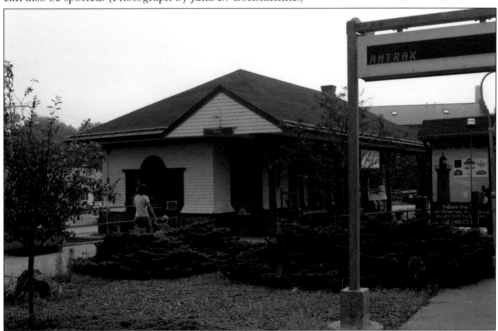

The Mystic Depot, pictured in July 2006, was built in 1905 and now serves Amtrak's Northeast Regional train at 2 Roosevelt Avenue. It is the third depot built on this spot. The depot served as the inspiration for American Flyer's talking toy train station, made in the mid-1900s. David and Sherrie Crompton plan to open a café and gift shop (Mystic Depot Roasters) in the depot in 2016. (Photograph by Geoff Hartland.)

Sea View Snack Bar, a seafood shack on the banks of the Mystic River, has been drawing hungry crowds since 1976 when owners Bill and Mary Botchis and their family took over the vacant spot referred to as "Picture Point." They have since opened Twisters next door to sell ice cream. A favorite of diners at Sea View is the lobster roll. (Courtesy of the Botchis family.)

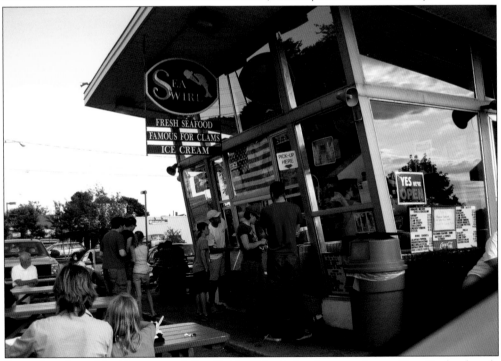

Formerly a Carvel Ice Cream stand, Sea Swirl of Mystic has been serving up New England–style fried foods and a variety of ice cream flavors for more than 25 years. It is known for its fried whole belly clams. Sea Swirl is a classic summer roadside eatery with waterfront seating along Pequotsepos Cove, located across from the Inn at Mystic on busy Route 1. (Photograph by David Bruce.)

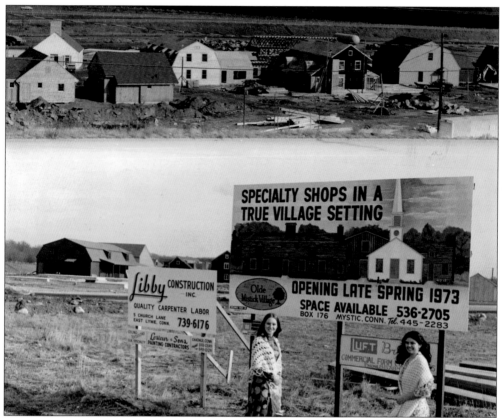

In the image above, Olde Mistick Village (OMV) is seen during construction before opening day in 1973. It is hard to imagine such open space in an area that is now fully developed with hotels, restaurants, and businesses. OMV has grown into a quaint center filled with a melting pot of over 60 shops, restaurants, a boutique movie theater, and a visitor center. OMV is a colonial-style shopping center designed to resemble a New England village in about 1720. Martin Olson (irrevocable trust), Joyce Olson Resnikoff (primary trustee), and her brother Jerry G. Olson (secondary trustee) own Olde Mistick Village. Many events are hosted here throughout the year, including Taste of Mystic, a garlic festival, and the Annual Cabin Fever Festival & Charity Chowder Cook-Off. (Both, courtesy of OMV.)

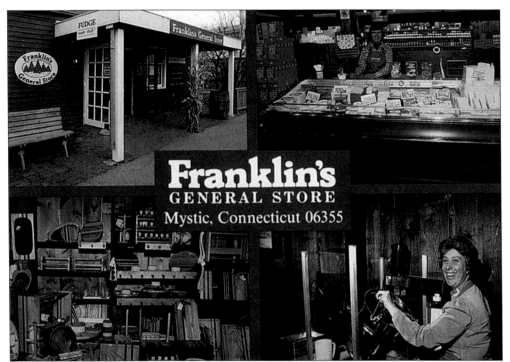

Franklin's General Store at Olde Mistick Village celebrated its 30th year in 2015. Twenty-one flavors of fudge are made daily, and more than 33,000 pounds are sold annually. Franklin's sells fresh roasted nuts, a variety of cheeses (reminiscent of the store's former life as a Hickory Farms franchise), and New England–made gifts. The all-American general store takes shoppers back to a time when life was simpler. (Courtesy of James Holley.)

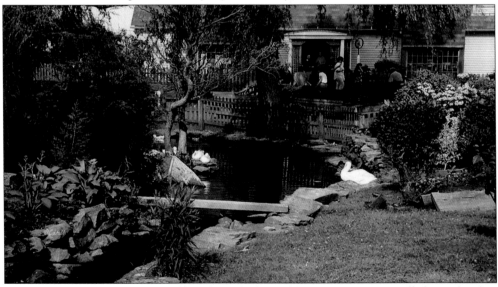

The duck pond at Olde Mistick Village (OVM), pictured here in 1995, is centrally located within OMV and home base to many ducks, who are fed twice a day by staff members. The pond is a big attraction for people of all ages, but especially for the little ones. There are several benches alongside the pond for relaxing in the shade. (Photograph by William B. Cahill, Trecrowns.)

The House of 1833 Bed and Breakfast at 72 North Stonington Road is a Greek Revival mansion with five guest rooms and 19th-century furnishings throughout. The building was home to Town and Country Clothes, a dress shop, from 1940 to 1980, then became a bed-and-breakfast in 1994. Innkeepers Robert Bankel and Evan Nickles purchased the property in 2005. (Photograph by Evan Nickles.)

At the time of this photograph, the Spicer Mansion at 15 Elm Street (across from the Mystic & Noank Library) was a building of apartment units owned by Robert Bankel and Evan Nickles. It was purchased by the Gates family of Stonington in 2013 and, in consultation with Ocean House Management, LLC, converted to a luxury boutique hotel in 2016. Many architectural details from the original 1853 home were preserved during the expansive renovations. (Photograph by Evan Nickles.)

A Stonington police officer directs traffic at the corner of East Main Street and Willow Street during the filming of *Mystic Pizza* in October 1987. The movie was filmed in Mystic and the surrounding area, with the restaurant scenes shot at 70 Water Street in Stonington. (Courtesy of Mystic River Historical Society.)

The Greater Mystic Chamber of Commerce began printing the "Visitors' Guide to Connecticut's Seafaring Town" in 1982, a response to an increase in tourism. This is the cover of the 1983 edition, which includes an advertisement for an audio tour with cassette and player and a calendar with a 10th anniversary celebration for Olde Mistick Village and the Marinelife Aquarium, scheduled for the last three weekends in September. (Courtesy of Greater Mystic Chamber of Commerce.)

61

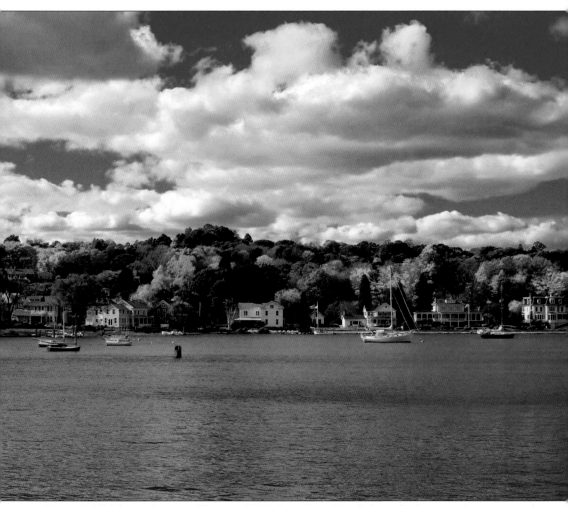

Mystic's fall foliage, showcased here in 2008 along River Road, draws leaf peepers from near and far. With the changing of the leaves in southeastern Connecticut, fall brings food and wine celebrations like Jonathan Edwards Harvest Festival in North Stonington, apple wine tastings at B.F. Clyde's Cider Mill, Restaurant Week in downtown Mystic, and other seasonal fun nearby, like the pumpkin patch and apple picking at Whittle's Willow Spring Farm. (Photograph by Stephanie McDowell.)

Five

AROUND "TOWN"

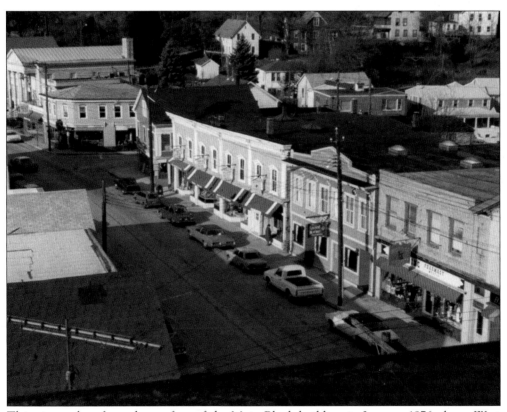

This view, taken from the rooftop of the Main Block building in January 1976, shows West Main Street. From a distance, it appears much the same as it does today; however, it was quite different back then. There was a pharmacy, a friendly diner, and a meat market, and trolley tracks ran down the middle of the street (no longer in use). Today, the buildings have been restored, businesses have changed hands, and downtown attracts visitors to the area. (Photograph by Julia B. Constantine.)

William Bendett was a West Main Street men's and women's clothing and shoes retailer since it was opened by William Bendett in 1900. This was its location in 1963 when it was owned by Bendett's grandsons William and Edward Tompkin. The store closed in the mid-1990s. (Courtesy of Norton and Mary Wheeler.)

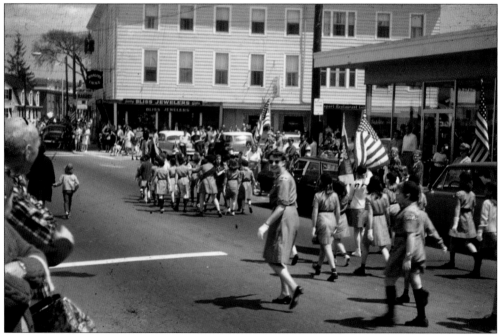

Brownie troops march on East Main Street in a c. 1963 Memorial Day parade. Beyond them, at the corner of Cottrell Street, the Whaler's Inn can be seen, with Bliss Jewelers on the first floor. This portion of the inn burned in 1975, but was rebuilt according to its original design. Another jeweler, Mallove's, now occupies the corner shop. (Courtesy of Norton and Mary Wheeler.)

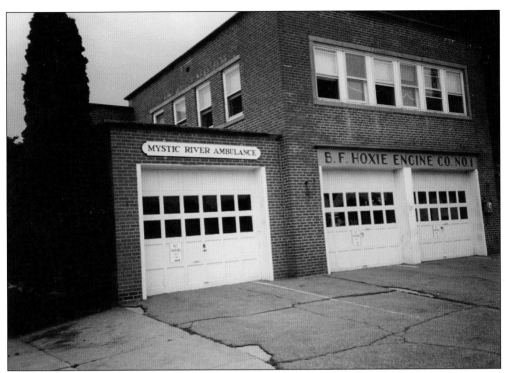

The Cottrell Street station was home to B.F. Hoxie Engine Co. from 1949 to 1992 when the company outgrew it. The building has since been converted into private residences. The department relocated to 34 Broadway Avenue, where Chief Frank "Fritz" Hilbert can see his childhood home from his desk at the station. Annual fundraising fish-fry dinners are held at B.F Hoxie on Fridays during Lent. (Courtesy of Mystic bridge tenders.)

Tom Santos, a longtime resident, is shown here in the late 1950s in his Explorer Scout uniform outside of the Odd Fellows Hall on the corner of Cottrell and Haley Streets. He remembers marching in Mystic's 300th anniversary parade, fighting the big fire of 1960 with his pajamas under his jeans, and setting pins at the Mystic Bowling Alley on West Main Street. Tom experienced Mystic's transition from village to tourist destination firsthand. Read more about his personal memories in his book *Mystic in the 1950s: Growing Up in a Small Village.* (Courtesy of Tom Santos.)

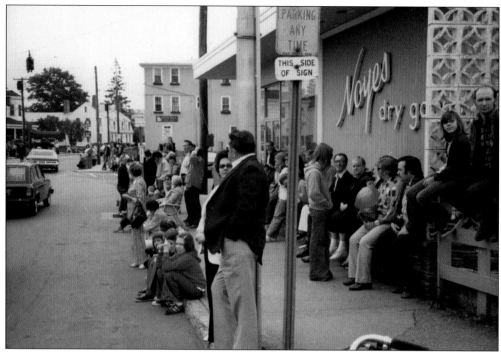

Noyes Dry Goods was in business for 117 years and at this location on East Main Street since the 1930s. The retailer, which sold clothing, linens, and draperies, among other items, was run by three generations of Noyeses. It was in the hands of Katherine Noyes Fuller and her husband, Daniel B. Fuller, at the time of this photograph in 1976. Mystical Toys currently occupies the building. (Photograph by Julia B. Constantine.)

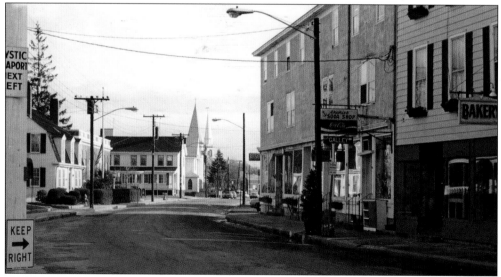

Archie's Soda Shop and Luncheonette, seen right of center in this photograph from 1973, was owned by Arthur "Archie" Radicioni, a life-long Mystic resident, and his wife, Esther, from 1946 to 1977. For more than 30 years, Arthur raised and lowered the American flag at the Liberty Pole, seen far left, situated on the opposite side of East Main Street. (Courtesy of Mystic River Historical Society.)

This picture of West Main Street with a view facing east toward Gravel Street was taken on New Year's Day in 1973. Mystic Sporting Goods (right foreground) was referred to by locals as "Neff's" after the owner, Richard Neff; this space has been occupied by Bank Square Books since 2013. Visible on the left side of the street are signs for Torhan Jewelers (foreground), Mystic Floorcovering, Calkins' Meat Market, Ancient Mariner, and Palau Rexall Pharmacy. (Courtesy of Mystic River Historical Society.)

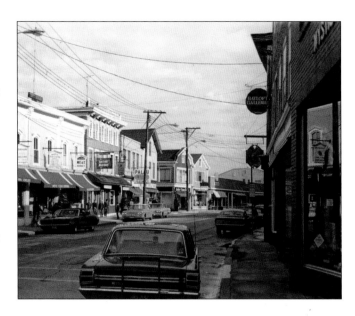

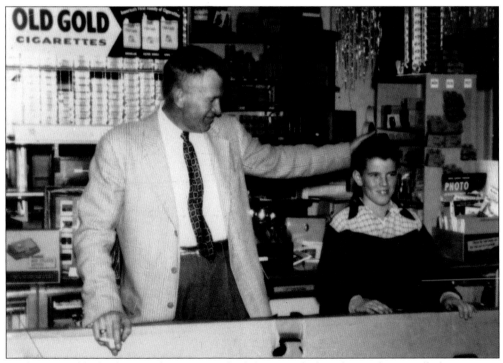

Twelve-year-old Charles "Sandy" Ferguson (right) received a bicycle at Palau Rexall Pharmacy on West Main Street in 1955 from store owner William Palau (left). Customers put names of local children into a contest run by Palau, and Ferguson received the most votes. Palau had purchased Gaskell's Drug Store in 1954 from Edward Gaskell. (Courtesy of Janet Purinton.)

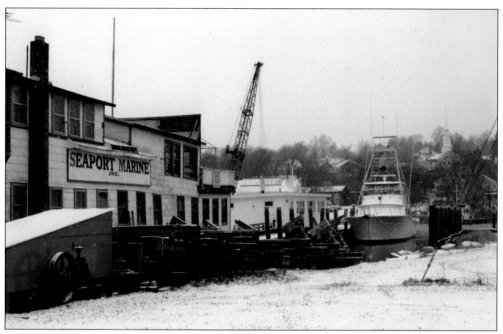

Seaport Marine at 2 Washington Street, pictured here during a snowstorm in 1989, has been under Noank Shipyard, Inc. ownership since 2004. It offers dockside, transient, maintenance, and mechanical services on the Mystic River. The Red 36 restaurant opened on the property in 2014. (Photograph by Julia B. Constantine.)

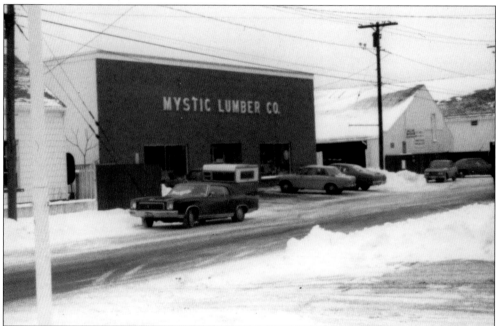

The 9,000-square-foot Mystic Lumber Co., pictured here in 1976, closed in 1996 after company president Raymond Bradley's retirement. The main building of the lumberyard and hardware store at the 44 Washington Street location was destroyed by fire in 1966 and rebuilt the same year. (Photograph by Julia B. Constantine.)

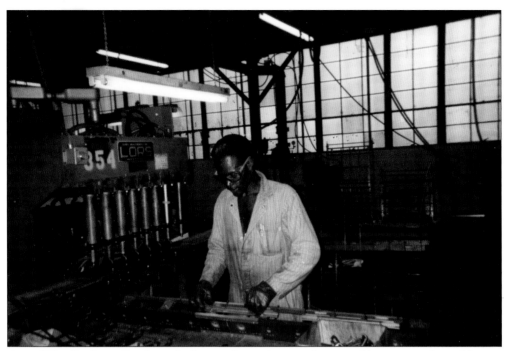

Acme Wire Products Co., Inc., the largest domestic manufacturer of lacrosse masks and largest wire fabricator in Connecticut, is a second-generation family business located at 7 Broadway Avenue Extension since 1979. Founded in 1970, it currently has 49 employees and makes precision industrial components from steel and stainless steel wire. This 1990 photograph shows an employee loading a weld fixture for a multiple-head welder. (Photograph by Mary Fitzgerald.)

This aerial image, captured from the west, shows an area of town just north of Murphy Point in 1979. The large building is home to Acme Wire Products Co., Inc., the marina in the lower right corner is Gwenmor Marina, and above is Mystic Shipyard East, all currently in operation. (Courtesy of Acme Wire Products Co., Inc.)

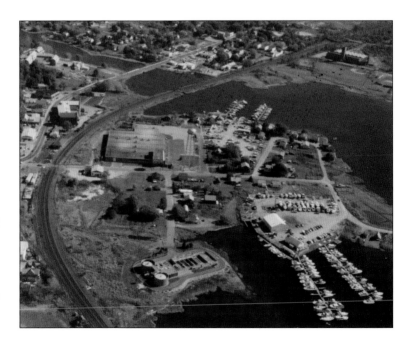

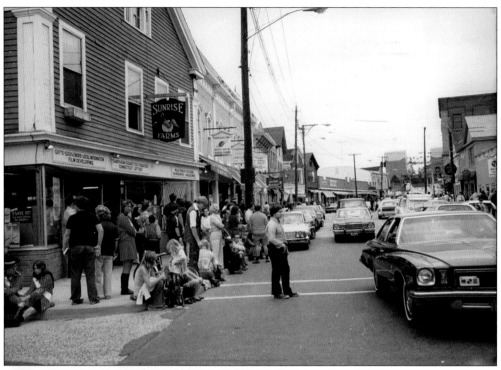

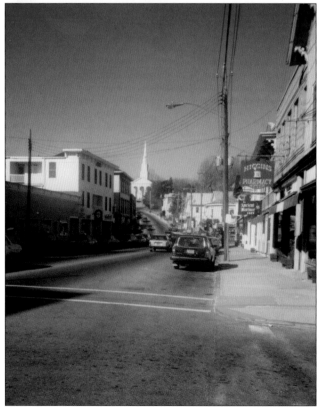

Sunrise Farms convenience store (previously Kretzer's), pictured here on May 30, 1976, was a long-standing downtown staple at 46 West Main Street. It was sold and became Crickets General Store in 1994 and then a Ben & Jerry's shop in 1995; the space is currently occupied by Bartleby's Cafe. (Photograph by Julia B. Constantine.)

This view of West Main Street facing toward Union Baptist Church was captured in March 1986. The Higgins' Pharmacy (right) replaced Palau Rexall Pharmacy in 1975. The first thing the Pawcatuck firm did was install air-conditioning, but it told the *Day* newspaper it would keep "the friendly and efficient sales people that Bill Palau has employed here at Mystic." Peppergrass & Tulip now occupies the site. (Courtesy of Joan MacGregor Thorp.)

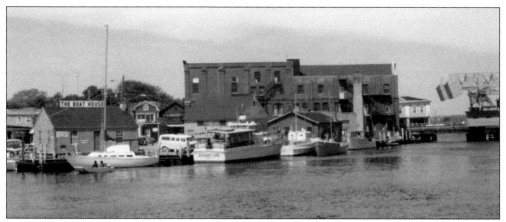

The brick building pictured center on West Main Street in 1976 was constructed in 1909 for Gilbert Transportation, one of Mystic's last shipbuilders. It later housed a silent movie theater until a 1915 fire. Once known as the Main Block after William L. Main, who purchased it in 1924, it was acquired by the Steamboat Wharf Company in 1975 for apartments and shops. (Photograph by Julia B. Constantine.)

The Jolly Beggars, pictured in June 1975, was a pub purchased by Michael Friedman in 1976. The Jolly Beggars hosted such musicians as Pete Seeger and Richie Havens, who stayed on Friedman's boat behind the pub. Jimmy Buffett also played at "the Beggars" before it was torn down. The Condos at Steamboat Wharf, built in the early 1980s, now occupy the site. (Photograph by Julia B. Constantine.)

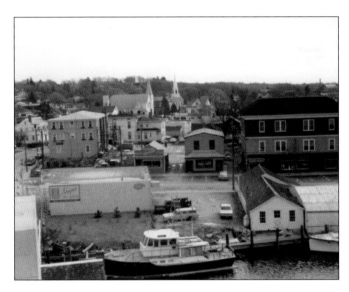

John's Mystic River Tavern (center) is located at 9 Cottrell Street in a former firehouse built in 1935 and pictured here between the Whaler's Inn (left) and French Cleaners in 1973. The Whaler's Inn burned down two years later, in 1975, but was rebuilt to its original design. John's, an Irish pub established in 1967, is currently owned by Timothy Murphy, who hosts old-time music sessions with musicians every Monday night. (Photograph by Julia B. Constantine.)

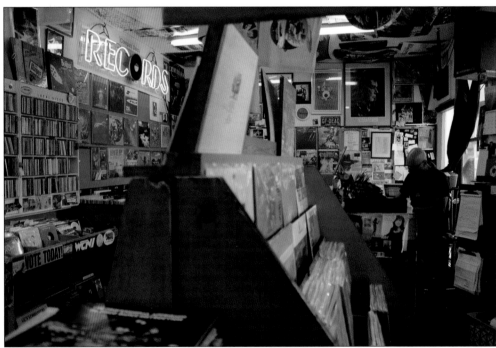

Mystic Disc, located on Steamboat Wharf on an alley off West Main Street, has been a hidden gem to vinyl diehards near and far. Owner Dan Curland opened the 300-square-foot shop in 1983 and has remained rooted in tradition, withstanding the emergence of CDs and digital music. "The Disc" is one of the longest-standing retail establishment in downtown Mystic. (Photograph by Kent Fuller.)

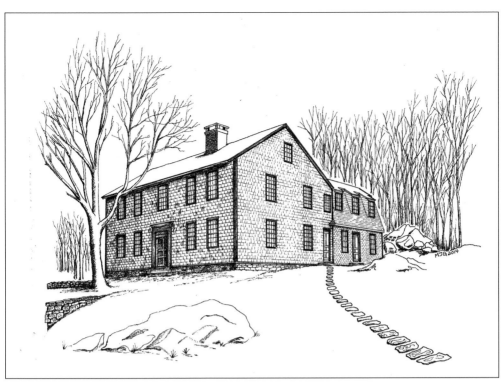

The Pequotsepos Manor is a 1717 house museum in which each room represents a different period in American history. It sits on Denison Homestead's 160-acre property covered in woodlands and meadows. The site was placed in the National Register of Historic Places in 1979. This illustration and others like it are to be found in *More Landmarks You Must Visit in Southeast Connecticut*, by Constant Waterman (aka Matthew Goldman). (Illustration by Matthew Goldman.)

The gardens of Enders Island, and Fishers Island Sound beyond, are pictured in 2010. Alys E. Enders donated her estate to the Catholic Church upon her death in 1954. The island's mansion and chapel, displaying relics such as the actual withered arm of St. Edmund, who preached for the Sixth Crusade in 1228, are used for retreats, 12-step recovery programs, sacred-art workshops, and daily Mass. (Photograph by Marion Krepcio.)

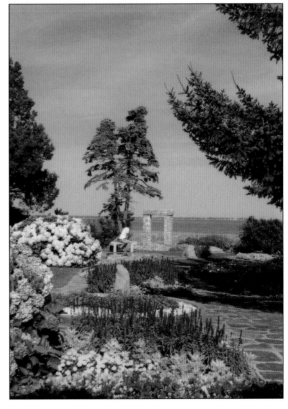

Nora Kaszuba was hanging out downtown on the north side of the Mystic River Bascule Bridge when she peered over the edge and observed these people in a boat attempting to maneuver unsuccessfully underneath the bridge. People were shouting good-naturedly from the bridge, and there was a lot of laughter to be heard. Kaszuba captured this shot before the group turned around and headed upriver. (Photograph by Nora Kaszuba.)

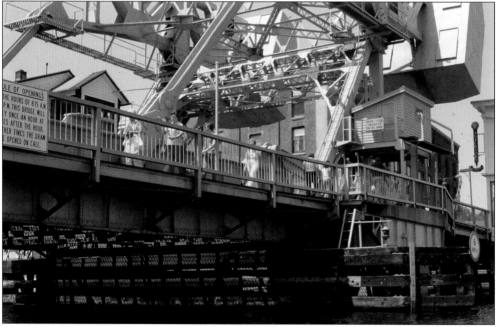

The Mystic River Bascule Bridge, constructed in 1922, connects the Groton side of Mystic on the west of the river to the Stonington side on the east. It underwent a successful rehabilitation process from 2000 to 2013 that replaced the open-grid steel deck and sidewalk system, replaced the operator house, and lowered the electrical motors into machinery pits beneath the sidewalks, a feature of the original design. (Photograph by Julia B. Constantine.)

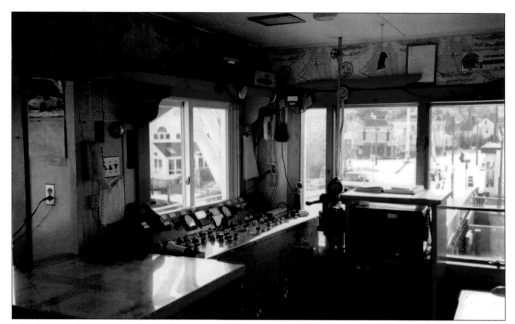

The Mystic River Bascule Bridge control house is staffed 24 hours a day during busy months. House accommodations include a refrigerator, microwave, coffeemaker, television, radio, and couch. The controls have become more technologically advanced over the years. The controls in this photograph are now used as backup since computerized screens were installed. (Courtesy of Mystic bridge tenders.)

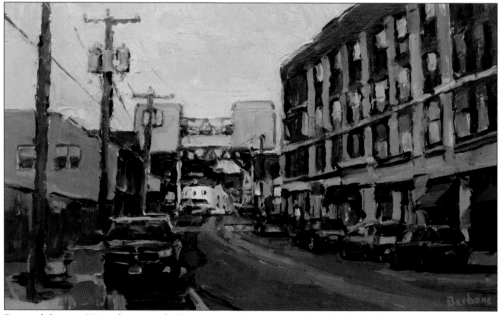

Painted from a 2011 photograph, *Downtown Mystic*, an oil by Sheila Barbone, depicts a view of West Main Street facing the drawbridge. Barbone included the "temporary" fence (left) erected after the Central Hall Block was destroyed by fire in 2000. "I loved watching children peek through the holes," she said. She painted this 9-by-14-inch image as a demonstration for her Modern Impressionism students at the Mystic Arts Center. (Painting by Sheila Barbone.)

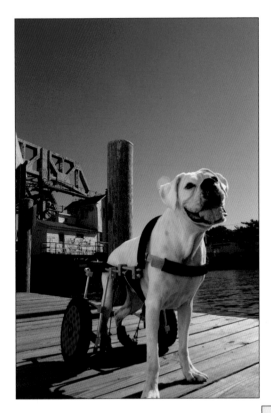

With several shopkeepers offering him water and biscuits, Clancy, a rescue boxer with degenerative spinal disease, enjoyed daily strolls through town assisted by his cart and owners, MaryBeth and Matthew Teicholz. He is seen here in 2011 in front of the drawbridge. He passed away that same year after a long, happy life. (Photograph by Matthew Teicholz.)

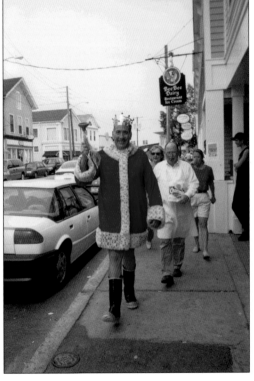

Peter Pappas, owner of the much loved Bee Bee Dairy restaurant (in business from 1975 to 2000) on West Main Street, is seen here holding a toilet plunger and marching along the sidewalk on June 11, 2000, celebrating the opening of Mystic's first public restrooms. Before there was a public bathroom, Bee Bee Dairy dealt with non-patrons using its lavatory. (Courtesy of Greater Mystic Chamber of Commerce.)

Six

IMAGES OF CHANGE

Prior to the development of Steamboat Wharf in the late 1970s and early 1980s, the dock and surrounding property (located across the river from Cottrell Lumber Company) was a much different place than it is today. There was a popular watering hole, an icehouse, and a number of old shacks scattered about. The area was pretty run-down, but a fond memory to many Mystic locals. (Photograph by Julia B. Constantine.)

A group of three investors—Paul A. Connor, H. Wes Maxwell, and John C. McGee—formed Steamboat Wharf Company and transformed the area just southwest of the drawbridge. The first condominiums in Mystic were developed, the Main Block building and its apartments were remodeled, and an upscale restaurant named Steamboat Cafe was built. Today, the Steamboat Wharf complex is filled with condominiums, a large paved parking lot, and waterfront lodging where the former Steamboat Cafe stood. The wooden dock is secure and even landscaped. The waterfront overlooks Mystic River Park, which was built a number of years later. (Both photographs by Julia B. Constantine.)

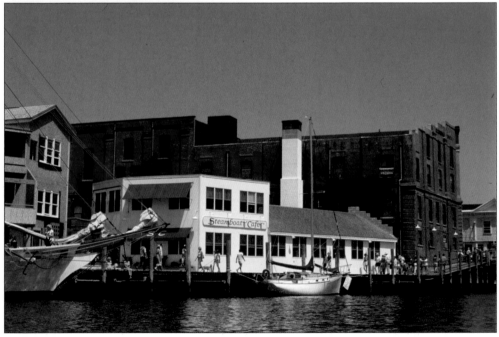

Condos and commercial space were planned to replace the former Cottrell Lumber Co. property, but plans fell through. In 1993, the people of Mystic approved contributing $1.5 million of fire district taxes to purchase the property and convert it into a waterfront park and dock. The fire district purchased the land at auction at a price of $690,000 with funds from a short-term loan granted by the Mashantucket Pequot tribe. Leaders from the Greater Mystic Chamber of Commerce, Mystic Rotary Club, and Mystic fire district all had hands in planning for the park. An additional $85,000 was donated by community members to put in the three-tiered dock entrance that was originally eliminated from the project to cut costs. The new Mystic River Park and dock opened in 1995. (Both, courtesy of Mystic River Park Commission.)

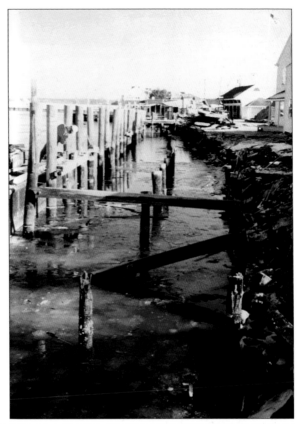

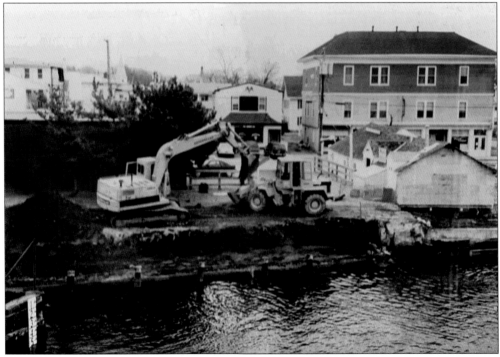

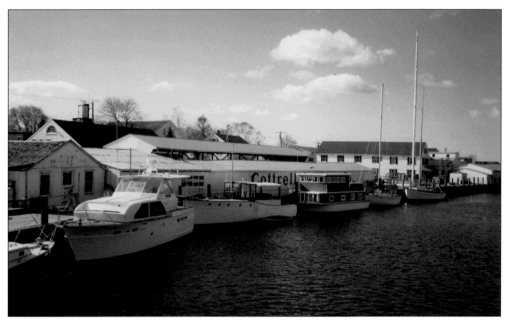

Cottrell (correctly pronounced "cot-rul") Lumber Co., where Mystic River Park is today, was founded in the early 19th century by Joseph Cottrell and is believed to have been the first lumberyard in Connecticut and second in all of New England. Through its time, Cottrell's lumberyard was passed down five generations, but it always provided great customer service selling materials to vessel and home builders. The final owner, William B. Dodge, expanded operations to include a hardware store and Cash and Carry. He sold the property to Cottrell Landing Limited Partnership, a Noank development company, and closed his business in 1988. (Above, courtesy of Joan MacGregor Thorp; below, photograph by Julia B. Constantine.)

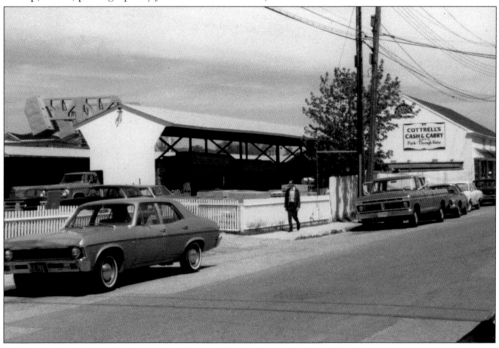

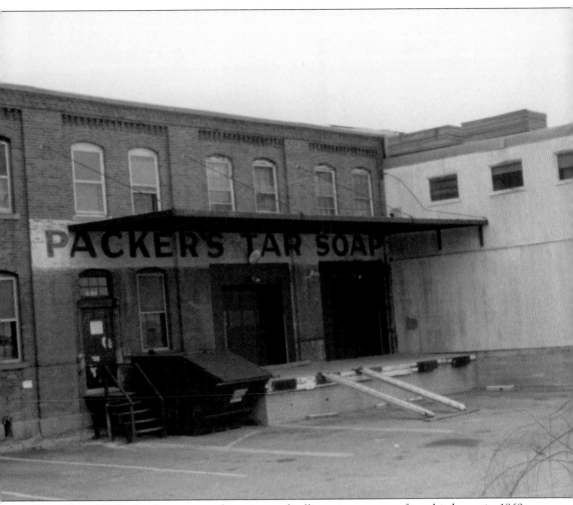

Capt. Daniel F. Packer began manufacturing and selling pine tar soap from his home in 1869. He moved his business into this factory on Roosevelt Avenue in 1906. Pictured in 1976, Packer's Tar Soap had moved out of the area in 1967 and is now called Packer's Pine Tar Soap. The Mystic Packer Building is now a professional center and home to the Greater Mystic Chamber of Commerce. (Photograph by Julia B. Constantine.)

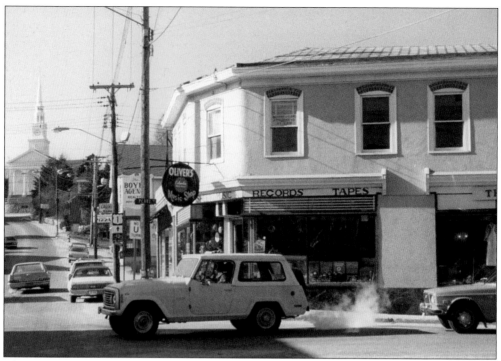

Oliver's Music Shop, seen here in 1976, was a West Main Street fixture for more than 30 years. It sat on the corner of West Main and Pearl Streets. Originally run by Oliver Bessette, it was later taken over by his son Ted Bessette, who ran the business on his own until it closed in 1982 as the rising rent became too much for the small village shop. (Photograph by Julia B. Constantine.)

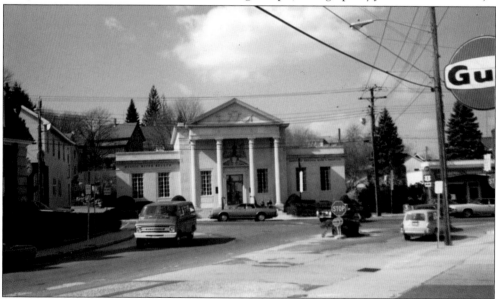

Built in 1931, Hartford National Bank on West Main Street looked like this in 1976. It is now the Bank of America, and other banks in this building have included Groton Savings Bank, Connecticut National Bank, and Fleet Bank. Tom Santos, born 1942, remembers opening his first account there when he was 11. (Photograph by Julia B. Constantine.)

A car dealership on Holmes Street makes way for 16 waterfront condominiums in 1983. The car lot originally belonged to longtime community member Joseph Santin until his retirement in 1972, when he sold to the Valenti family. The condos, also a Valenti venture, were originally listed in the $200,000 to $265,000 range in 1984. One of the two-bedroom units sold for $710,000 in June 2015. (Courtesy of Joan MacGregor Thorp.)

In the 1970s, one could do his or her grocery shopping at the IGA Colonial Market, owned by John McTurk, an original tenant of Olde Mistick Village when it opened in 1973. The store was later transformed into the restaurant Go Fish, still operating today. (Photograph by Julia B. Constantine.)

The Captain Daniel Packer Inne (DPI), constructed in 1756 by Capt. Daniel Packer, was once a landmark stop for travelers between Boston and New York. The property remained in the Packer family and then with their descendants, the Keelers. In the mid-1960s, the building was vacant, fell into disrepair, and remained abandoned until 1979 when Richard "Dickie" Kiley and his wife, Lulu, purchased it and began a three-and-a-half-year renovation. Richard commuted from his Rhode Island home and slept many nights by the fireplace after long days of renovation. Richard did most of the work himself, with some help from friends. The Kileys completed their renovation in 1983 and opened the Captain Daniel Packer Inne as a restaurant and bar on November 17. (Both, courtesy of DPI.)

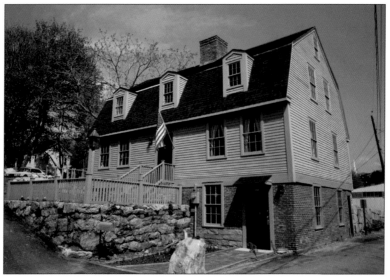

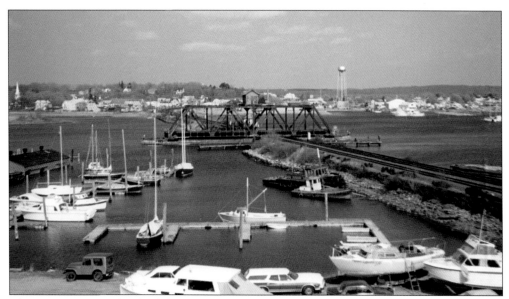

The 25,000-ton, 69-foot-high-by-33-foot-wide Mystic River Railroad Bridge is located near the Fort Rachel area of Mystic, which has changed dramatically over the last 30 years. Although the Mystic bridge tenders and railroad bridge tenders, separated by approximately a quarter mile, operate independently, they coordinate efforts for commercial vessels and special events. The 150-foot-tall water tower on Broadway Extension is seen in the distance. (Photograph by Julia B. Constantine.)

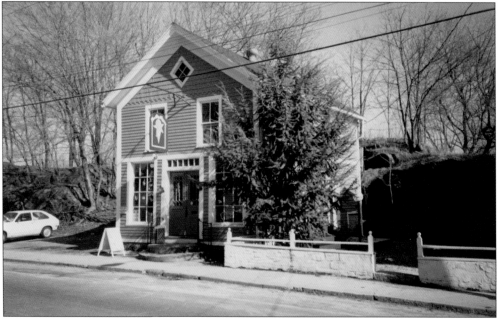

The property at 13 Water Street in West Mystic has seen its fair share of restaurants. Pictured in this c. 1985 image is the Ice Cream Parlor. Today, Oyster Club, a farm-and-sea-to-table restaurant occupies the transformed building and draws in locals, visitors, and even famed chef Jacques Pépin, who said that his meal at Oyster Club was one of the best he had in years. (Courtesy of Joan MacGregor Thorp.)

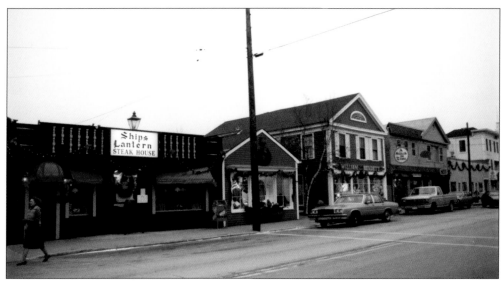

West Main Street storefronts are decorated for the holidays in 1985. Ship's Lantern Steak House, owned by Leroy "Giaco" Broccoli until 1993, was where Ancient Mariner is today. A Stitch in Time, in the Yellow Brick Mall on the right, was opened in 1973 by owners Larry and Jeanne Gemma. Larry later opened Mystic Army Navy Store with co-owner Bert Dahl in 1993, while Jeanne continued running A Stitch in Time until 2000. (Photograph by Julia B. Constantine.)

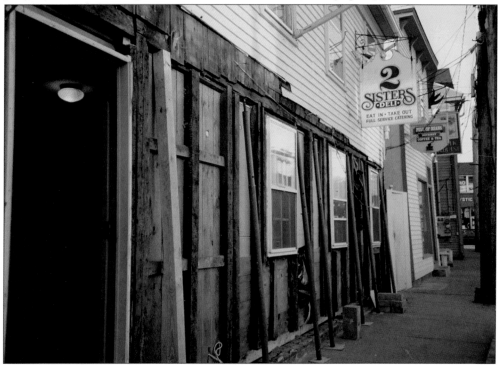

The building at 4 Pearl Street was erected around 1868 and the Daughters of the American Revolution Fanny Ledyard Chapter held its meetings there. In the 1980s and 1990s, the building was occupied by 2 Sisters Deli, a sandwich spot. It is now home to an Irish pub, the Harp & Hound, or "the Harp," as it is known by locals. (Courtesy of Mystic bridge tenders.)

Seven

EVENTS

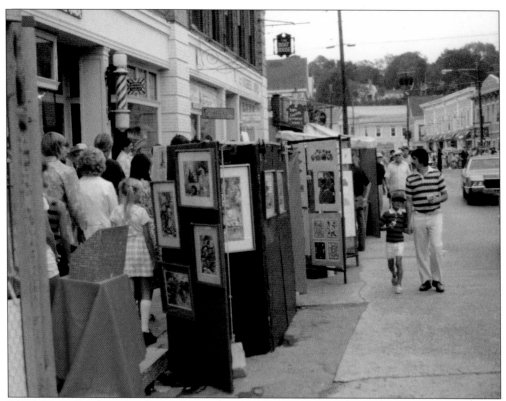

The Mystic Outdoor Art Festival, seen here in August 1976, is hosted by the Greater Mystic Chamber of Commerce and is the oldest of its kind in the Northeast. It began in 1958, stretches over two miles, and attracts close to 100,000 people each year. The festival has grown over time and now features close to 300 artists and artisans showcasing over 100,000 pieces. (Photograph by Julia B. Constantine.)

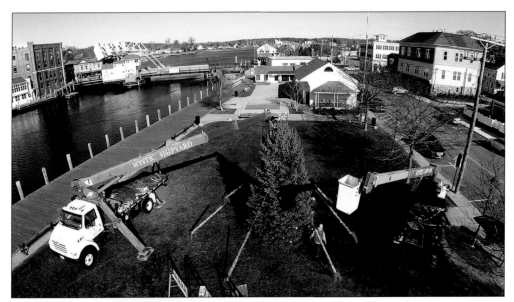

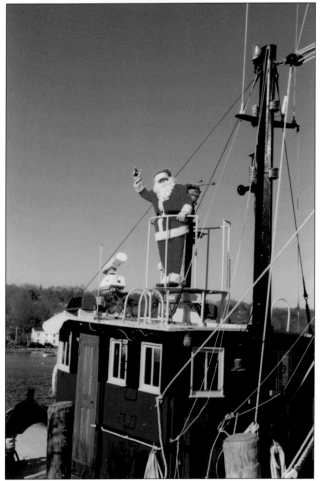

Every November, Mystic Shipyard's Jeff Marshall and his crew, along with M.J. Sauchuk, Inc., volunteer in acquiring, hauling, installing, and decorating a Christmas tree in Mystic River Park. It is later lit by Santa to kick-start an annual holiday tradition. The tree pictured was donated in 2015 by a Mystic resident from Judson Avenue whose evergreen had outgrown the yard. (Photograph by John Kueter.)

Santa makes his way up the Mystic River via tugboat to dock at Mystic River Park, where crowds gather awaiting his arrival. Santa is pictured in 1999 arriving on the *Kingston II* tugboat, which is no longer in service. The tugboat is now on display at the main entrance to Mystic Seaport. Presently, Santa rides the Cross Sound Ferry's *John Paul* tugboat. (Courtesy of Greater Mystic Chamber of Commerce.)

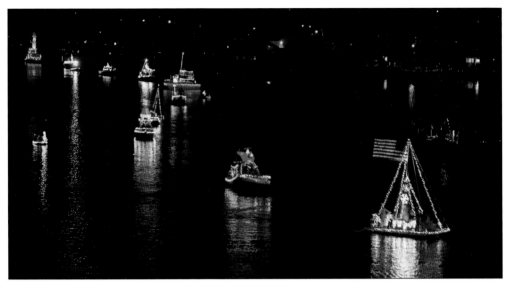

The Holiday Lighted Boat Parade, organized by the Greater Mystic Chamber of Commerce, began in 2003. This magical event takes place on the Mystic River from Mystic Seaport down to the Mystic River Railroad Bridge. There is a chill in the air, as it is held in late November, but it is a fun reason to bundle up with family and friends and embrace the holiday season. (Courtesy of Eastern Regional Tourism District/Mystic Country.)

The Antique and Classic Boat Parade, seen here in July 1981, is part of the Antique & Classic Boat Rendezvous at Mystic Seaport that began in 1975. Antique vessels such as cruisers, sailboats, and runabouts converge at Mystic Seaport from all over the country. The weekend culminates with a three-mile-long parade down the Mystic River, with each boat announced from Mystic River Park as it passes through the drawbridge. (Courtesy of the Clabby family.)

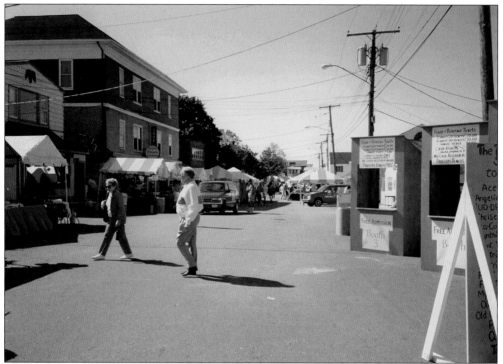

The Taste of Connecticut began in 1989 to benefit the Mystic Community Center. It was moved to New London as part of Boats, Books, and Brushes Festival in 2002 but brought back by popular demand in 2004 as the Taste of Mystic. It is a much anticipated annual event organized by the Greater Mystic Chamber of Commerce. Originally held downtown on Cottrell Street, the fun-filled foodie weekend now takes place at Olde Mistick Village. (Courtesy of Mystic bridge tenders.)

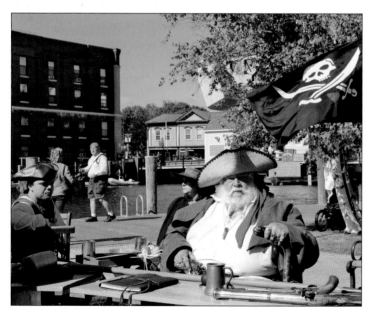

The Mystic Pirate Invasion began in 2013 and has become a popular event for locals and out-of-towners. The lawn of Mystic River Park is the headquarters of the invasion. Participants are encouraged to dress in their pirate best. There is a scavenger hunt around town, drink and food specials, demonstrations, and more. The event is put on by the Downtown Mystic Merchants. (Photograph by Meredith Fuller.)

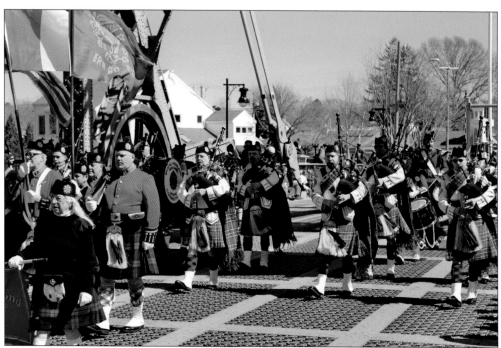

The Mystic Irish Parade began in 2004 and has grown into a much anticipated and loved event. The parade, drawing approximately 30,000 people, celebrates St. Patrick's Day and the Irish culture that is so prevalent in the community. It takes place in March on the streets of downtown Mystic. This is a photograph of the Mystic Highland Pipe Band crossing the Mystic River Bascule Bridge in 2015. (Photograph by Kent Fuller.)

One of the most memorable groups to participate in the annual Mystic Irish Parade was the Budweiser Clydesdales in 2008. A team of horses was transported here from its home base of Merrimack, New Hampshire, to march the parade route with wagon in tow from Greenmanville Avenue, over the bridge, and ending on Water Street. (Photograph by Beth Sullivan.)

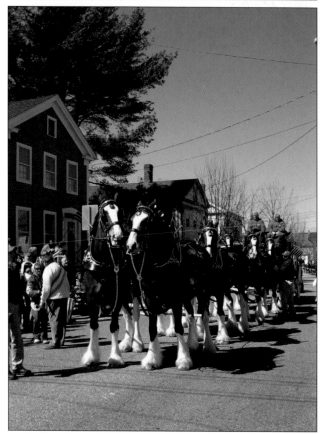

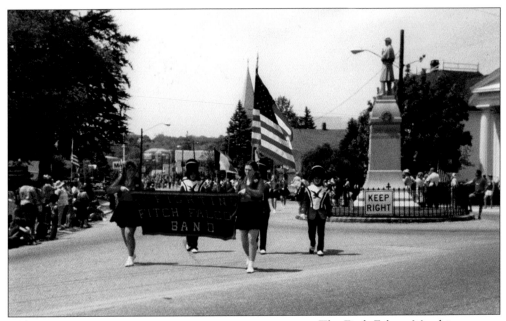

The Fitch Falcon Marching Band safely passes the Civil War Soldiers' Monument at the intersection of Broadway Avenue and East Main Street during the 1981 Memorial Day parade. When the monument was dedicated with a parade almost a century earlier on June 13, 1883, the gun salute was mistakenly fired into the oncoming marchers, causing gunpowder burn injuries, though none life-threatening. (Photograph by Janet Purinton.)

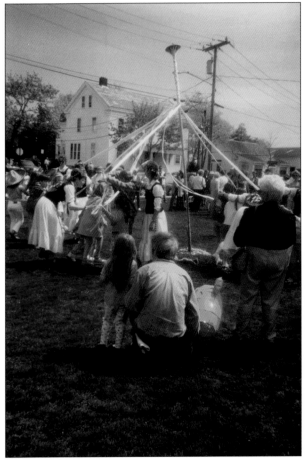

The annual Mystic May Day Celebration, sponsored by the Greater Mystic Chamber of Commerce, began in 1997 to rejoice in the arrival of warm weather. The celebrations included this maypole dance by the Mystic Garland Dancers pictured in Mystic River Park in May 1998. (Photograph by Judy Hicks.)

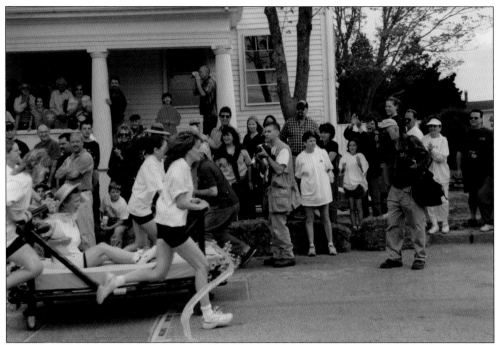

The May Day Bed Race, a highlight of the Mystic May Day Celebration, is pictured on May 2, 2001, as participants cross the finish line after the one-tenth-mile race down Cottrell Street. The celebration made way for the bigger and continuously growing Mystic Irish Parade, "which is now one of the largest in the state," according to Tricia Walsh, president of the Greater Mystic Chamber of Commerce. (Courtesy of Greater Mystic Chamber of Commerce.)

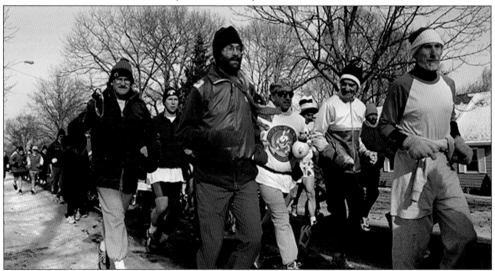

A New Year's Day tradition that was started in 1969 by three runners—Marty Valentine, Amby Burfoot, and Leland Burbank—the Run and Swim today involves warming up with a five-mile run from the John J. Kelley statue to Esker Point Beach, then stripping down and jumping into the frigid Long Island Sound. Pictured here in the late 1990s are participants, including 1968 Boston Marathon winner, author, and *Runner's World* editor Burfoot (in blue). (Photograph by W.R. Hurshman.)

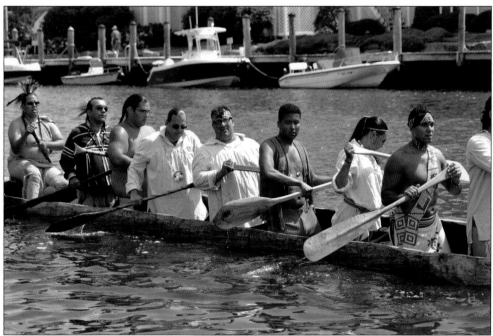

On August 8, 2015, the dugout canoe *Nookumuhs* made her maiden round-trip Mystic River voyage from Mystic to Noank, paddled by 12 representatives from six New England tribes—Mashantucket Pequots, Narragansetts, Schaghticokes, Passamaquoddies, Aquinnah and Mashpee Wampanoags, and the Shinnecocks from Long Island. The canoe was constructed using the traditional method of burning and hand scraping at the Mashantucket Pequot Museum & Research Center (MPMRC), a tribal museum opened in Mashantucket in 1998. (Courtesy of MPMRC.)

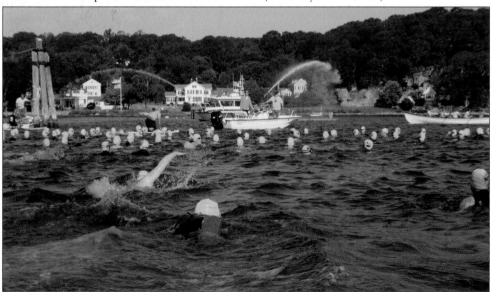

The inaugural Sharkfest swim took place on July 11, 2015. One hundred seventy-four competitors swam down the Mystic River—starting at Mystic Seaport, swimming under the lifted Mystic River Bascule Bridge, and finishing at Dock D of Seaport Marine next to Red 36 Restaurant. The swimmers' ages ranged from nine to 74 years old. (Photograph by Alanna Riley.)

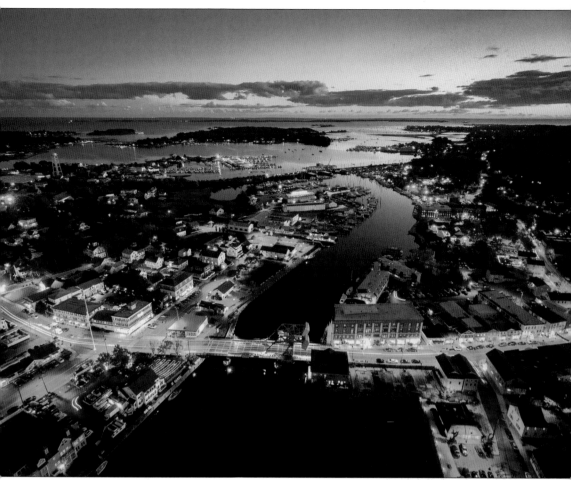

This overhead view of downtown Mystic and the Mystic River was taken from about 300 feet up. Mason's Island and Ram Island, which are within Mystic's borders, can be seen in the distance. The Mystic River Bascule Bridge, East and West Main Streets, and surrounding neighborhoods are brought to life in this aerial photograph taken via drone at dusk by longtime local photographer turned "droniac" Tim Yakaitis. (Courtesy of droneon.com.)

DISCOVER THOUSANDS OF LOCAL HISTORY BOOKS
FEATURING MILLIONS OF VINTAGE IMAGES

Arcadia Publishing, the leading local history publisher in the United States, is committed to making history accessible and meaningful through publishing books that celebrate and preserve the heritage of America's people and places.

Find more books like this at
www.arcadiapublishing.com

Search for your hometown history, your old stomping grounds, and even your favorite sports team.